D1110617

VISUAL EXPLORER GUIDE

CANADA

VISUAL EXPLORER GUIDE
CANADA

NORAH MYERS

amber
BOOKS

First published in 2020

Published by
Amber Books Ltd
United House
North Road
London
N7 9DP
United Kingdom
www.amberbooks.co.uk
Instagram: amberbooksltd
Facebook: amberbooks
Twitter: @amberbooks

Project Editor: Kieron Connolly
Designer: Gary Webb
Picture Research: Terry Forshaw

ISBN: 978-1-78274-960-8

Printed in China

Contents

Introduction

The word 'Canada' probably comes from the Iroquoian 'kanata'. It was first heard by French explorer Jacques Cartier in 1535 when two Iroquoian youths directed him towards the village of Stadacona. 'Kanata' merely means 'village' or 'settlement', not a particular place, but Cartier used 'Canada' to refer to the entire Stadacona region. From there, the word was applied to ever larger areas along the St Lawrence River. As European explorers and fur trappers opened up the territory, so the area known as Canada grew.

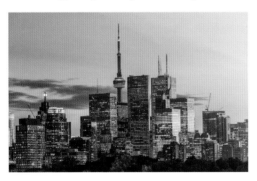

Today Canada is known for its forests and mountains, beautiful clear lakes and rivers, small towns and large cities. From the remote Inuit communities in the Arctic to the mild climes of Vancouver, from the prairies of Saskatchewan to the soaring peaks of the Rockies, from cities such as Winnipeg and Montreal, Toronto and Halifax, it is both Inuit, First Nations, French and English in origin. But more recent waves of immigrants have further enriched the vast nation and its culture. Today the country thrives on its dramatic landscape, robust weather and vibrant cities.

ABOVE:
Canada's most populous city, Toronto is a hugely multicultural metropolis.

OPPOSITE:
With places often inaccessible by road, seaplanes like this one in the Yukon are the workhorses of the north.

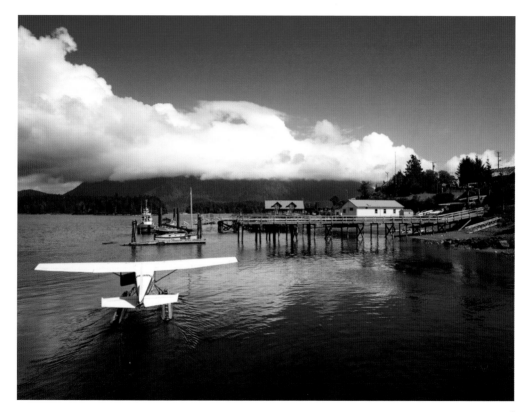

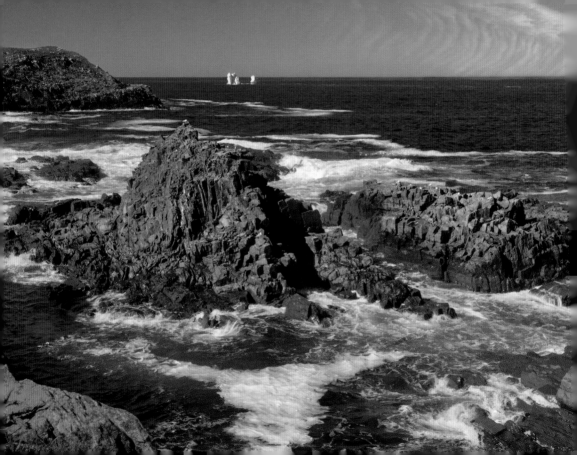

The Atlantic Region

Atlantic Canada consists of four provinces: the three Maritimes – New Brunswick, Nova Scotia and Prince Edward Island – as well as Newfoundland and Labrador, the latter being the easternmost province of the country.

The region covers 500,531 square km (193,256 square miles). With a temperate climate, mild summers and rainy winters, fishing and boat-based tourism are some of the region's most profitable industries. Its cuisine consists of a great deal of salmon, scallops and crab.

Atlantic Canada was the first region of the country that Europeans discovered, explored and settled, largely displacing First Nations people who already lived there. Today the region's traditions are strongly influenced by customs originating in Britain, Ireland and France. In fact, Newfoundland and Labrador remained a British dominion until well into the 20th century, only becoming a Canadian province as late as 1949. Atlantic Canada accounts for about 6.5 per cent of the country's total population.

OPPOSITE:

Near Elliston, Newfoundland
Icebergs, as can be seen here, are frequently spotted off the Newfoundland coast near Elliston. The Strait of Belle Isle separates the province into its two major geographical divisions: the mainland of Labrador and the island of Newfoundland.

**Grand-Pré National
Historic Site, Minas
Basin, Nova Scotia**
The Grand-Pré National
Historic Site and its
church commemorate
the Grand-Pré Acadian
settlement, which
consisted of descendants
of emigrants from
France and First Nations
people of the Wabanaki
Confederacy. They were
deported by the British
during the French and
Indian War (1754–63).

 The inlet of the Minas
Basin into the Bay of
Fundy can be seen in
the distance.

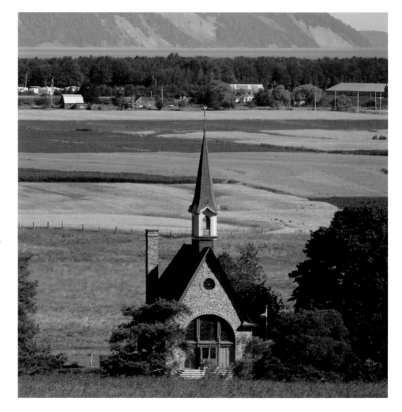

LEFT:

Green Gables Heritage Place, Cavendish, Prince Edward Island
Beginning with the first book's publication in 1908, Lucy Maud Montgomery's *Anne of Green Gables* stories have made Prince Edward Island a popular tourist destination. Her novels are about a young orphan sent to live with adult siblings who had in fact wanted to adopt a boy to help on their farm. Montgomery grew up and worked on Prince Edward Island as a teacher before finding success as an author.

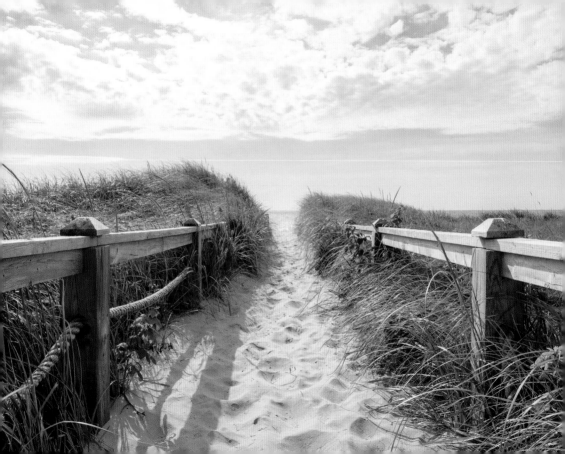

OPPOSITE:

**Basin Head, Prince
Edward Island**

Basin Head Beach is
known for its warm
waters, the warmest north
of Florida. Its unique
sand, with a high silica
content, 'sings' when
walked on.

RIGHT:

**Bay of Fundy, Hopewell
Rocks, New Brunswick**

Whereas most tides rise
and fall by around 1m
(3ft) a day, at Hopewell
Rocks, due to the
particular dimensions
of the Bay of Fundy, the
tidal change is 10–14m
(32–46ft) a day.

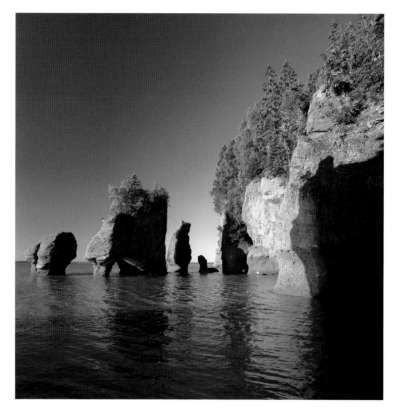

Cape Enrage Lighthouse, Bay of Fundy, New Brunswick

Dating from 1838, Cape Enrage Lighthouse is the oldest on the New Brunswick mainland. In the late 1980s, it was automated, and, left unmanned, it quickly fell into disrepair. In 1993, a group of school students from nearby Moncton helped to save it from demolition.

Sedimentary stone, Cape Enrage, Bay of Fundy, New Brunswick

The Bay of Fundy includes rare mineral deposits, such as agate, amethyst and stilbite.

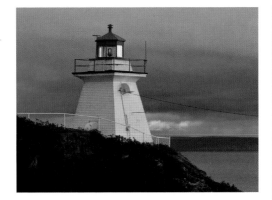

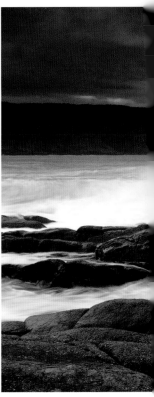

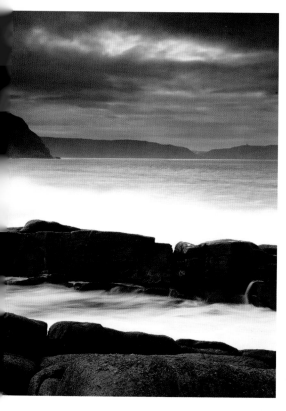

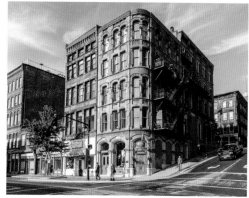

LEFT:

Cape Spear, Newfoundland

Excluding Greenland, this is the easternmost point in North America. The name has nothing to do with spears; in French, it is known as 'Cap d'Espoir', which means 'Cape of Hope'. English speakers adapted the sound of 'espoir' into 'spear'.

ABOVE:

Saint John, New Brunswick

Saint John built its wealth on shipbuilding in the 19th century. The city has one of the largest dry docks in the world, although in the 21st century its shipbuilding industry is no longer as active as before.

RIGHT:

House near Elliston, Newfoundland

Elliston, a small community located in Trinity Bay on the east coast of Newfoundland, was once known as Bird Island Cove, after the numerous seabirds, particularly puffins, that inhabited the unpopulated islands just off the coast. Elliston offers one of the closest land views of puffins in North America. Since 1992, the puffin has been Newfoundland and Labrador's provincial bird.

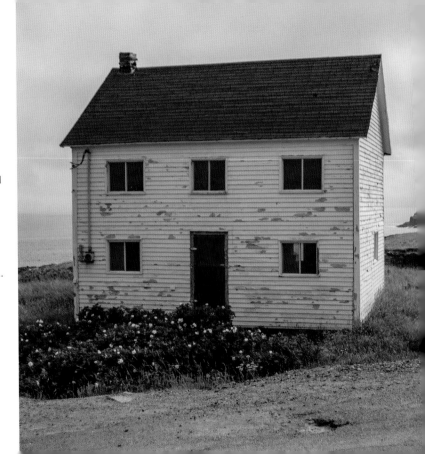

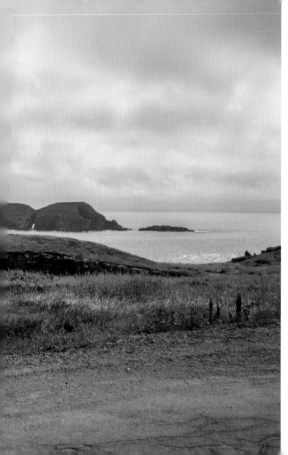

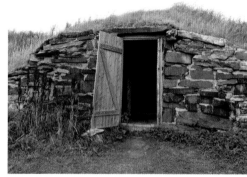

ABOVE:

Root Cellar, Elliston, Newfoundland

Elliston has more than 100 root cellars, more than half of which remain in use today. These underground food storage systems are built into small hills and banks. Before the island had electricity, root cellars were essential for surviving the winter.

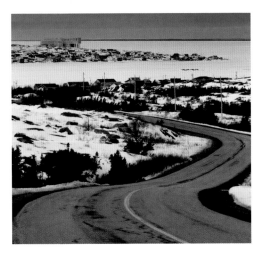

ALL PHOTOGRAPHS:

Fogo Island, Newfoundland

Fogo Island was visited by Portuguese and French fishermen before the Irish and English settled it in the 18th century. Its name comes from the Portuguese for 'Isle of Fire', as forest fires destroyed many of the trees on the island's northern part.

Members of the Flat Earth Society believe that one of the four corners of the Earth is Brimstone Head, an enormous rock that juts out of the island's northwestern coast.

Fogo Island Inn (opposite) opened in 2013. It was the dream of technology businesswoman and entrepreneur Zita Cobb, a native of the island who returned to build the high-end hotel there. The venture has helped stall the island's population slide – 50 years ago residents even formed the Fogo Island Co-Op to resist political pressure to be resettled. The hotel's stilt-structure echoes many of the island's older buildings, where the rocky, uneven ground makes conventional foundations unsuitable.

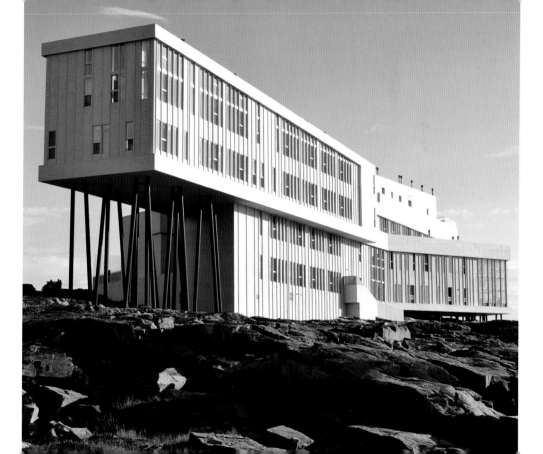

Swallow Tail Lighthouse, Grand Manan Island, New Brunswick

En route from Toulon in France to Saint John, New Brunswick, the merchant ship *Lord Ashburton* was wrecked in a storm off Grand Manan Island in January 1857. Twenty-one lives were lost. Of 10 men who made it ashore, two froze to death before help arrived. Two years later Swallow Tail Lighthouse, the island's first, was completed. Today the lighthouse has been restored, with a new footbridge and boardwalk connecting it to the surrounding area.

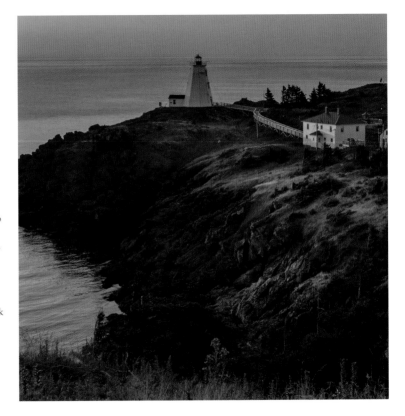

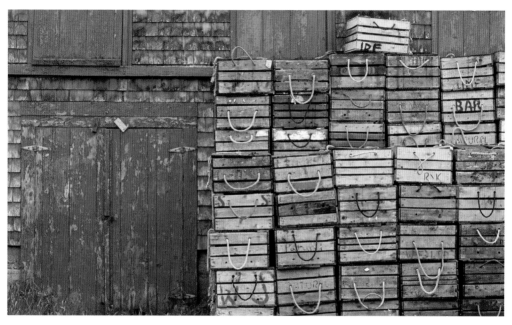

ABOVE:

Fishing crates, Seal Cove, Grand Manan Island, New Brunswick
Lobster, herring and scallops are the primary fish caught off Great Manan Island, which is also known as the dulse capital of the world.

Dulse is an edible seaweed that is harvested on the island's west side and exported as a condiment and seasoning.

Queen Street, Halifax, Nova Scotia

Colourful stacked houses like these, which can come in pink, yellow, red, green and blue, are commonly referred to as 'jellybean' houses. Where most of the homes in Atlantic Canada are built of wood rather than brick, residents have the luxury of making them whatever colour they like. There are many different myths about the origins of the painted houses, ranging from the desire to make homes visible to sailors at sea during foggy conditions, to the fact that maritime weather can sometimes be grey, so brightly coloured homes are a means to play a trick on Mother Nature.

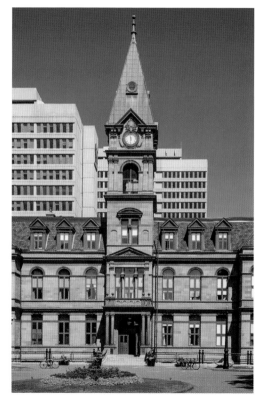

City Hall, Halifax, Nova Scotia

Halifax City Hall, erected between 1887 and 1890, is the largest and one of the oldest municipal buildings in Nova Scotia. The first floor of the building originally contained a police department and jail cells – from which Harry Houdini escaped in 1896.

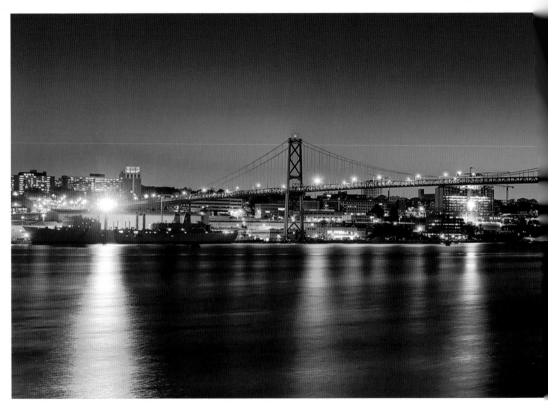

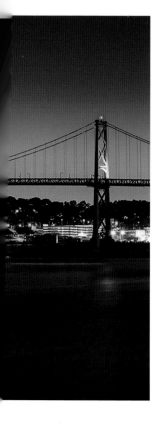

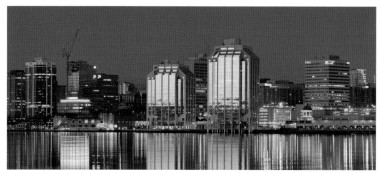

LEFT:

Angus L. Macdonald Bridge, Halifax Harbour, Nova Scotia

The Angus L. Macdonald Bridge, which links Halifax with Dartmouth, opened in 1955. Between 2015 and 2017, working at night and at weekends with the bridge remaining open during weekdays, all of the road deck, stiffening trusses and suspended spans were replaced.

ABOVE:

Waterfront, Halifax, Nova Scotia

Halifax Harbour is one of the deepest and largest natural, ice-free harbours in the world. Halifax Waterfront is home to one of the world's longest downtown boardwalks, at 4.4 km (2.7 miles).

Purdy's Wharf (the two office towers in the foreground of the image) has a unique, energy-efficient cooling system that works by circulating seawater through a heat exchanger system with the building's cooling water.

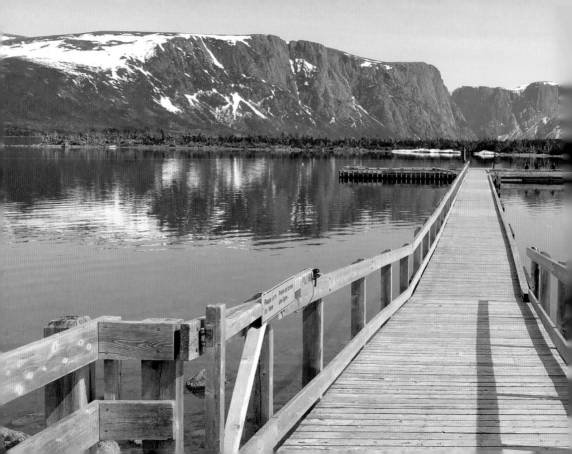

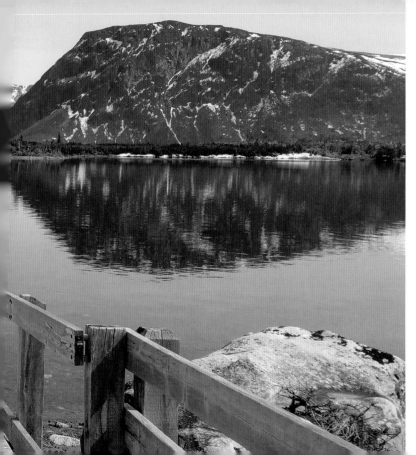

LEFT:

Western Brook Pond, Gros Morne National Park, Newfoundland
Gros Morne National Park's largest lake, Western Brook Pond, spans 16km (10 miles) with a depth of 165m (541ft). Arctic char, Atlantic salmon and Brook trout swim in the water. The fjord used to be saltwater, but the salt was flushed from it, leaving the water fresh.

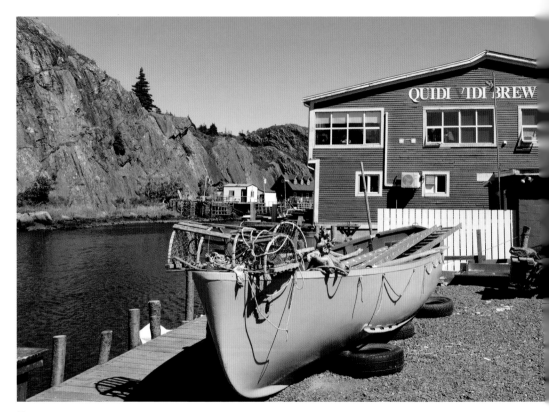

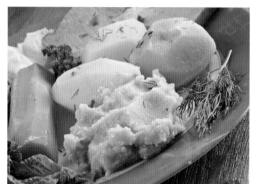

Quidi Vidi Brewing Company, Quidi Vidi Village, St John's, Newfoundland
Probably French in origin, Quidi Vidi is pronounced 'Kiddy Viddy'. The Quidi Vidi Brewing Company is best known for its Iceberg lager, which is made from water collected from icebergs off Newfoundland's coast.

TOP AND BOTTOM LEFT:
Jiggs dinner
A Jiggs dinner, traditional to Newfoundland and Labrador, is a meal typically served on Sundays, consisting of salt beef boiled together with cabbage, carrots, potatoes, and turnip. Jiggs dinners are also served around St Patrick's Day. It can be turned into a warming soup, too.

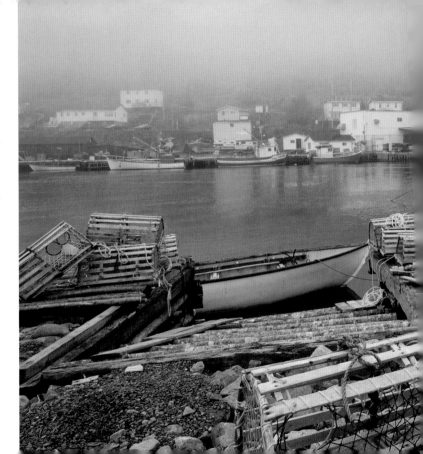

RIGHT:
Petty Harbour, Newfoundland
Petty Harbour is one of the earliest European settlements in North America: Basque fishermen were probably using it as a seasonal base by 1500, and by 1600 the English had taken it over. Its name comes from the French for 'small harbour' – 'petit havre'. Petty Harbour primarily relied on the fishing industry until 1992, when the government declared a moratorium on cod fishing. Today its primary industry is tourism.

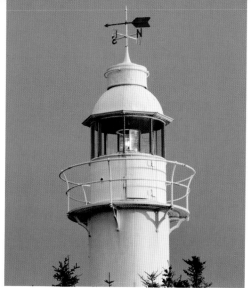

Lobster Cove Head Lighthouse, Rocky Harbour, Gros Morne National Park, Newfoundland

Made out of iron, Lobster Cove Head Lighthouse was opened in 1898. Before it was automated in 1969, there had only been three lighthouse keepers at Lobster Cove Head. Offshore, whales can be seen in Bonne Bay, while moose, caribou and arctic hare live within Gros Morne National Park.

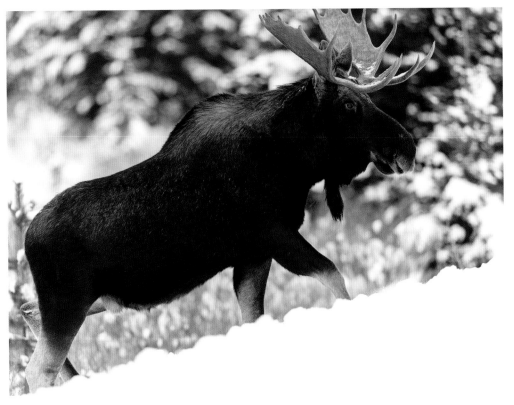

OPPOSITE:

Bull moose

A moose is actually a member of the deer family *Cervidae*. Unlike other deer, they do not form herds. They're solitary animals, and found across almost all of Canada, excluding Vancouver Island and the Arctic.

RIGHT:

Maple trees in autumn, New Brunswick

There are 10 maple tree species native to Canada. Unlike the other Maritime provinces, New Brunswick is mostly forested (83 per cent), but with less of a shoreline to moderate its temperatures it has a more severe climate.

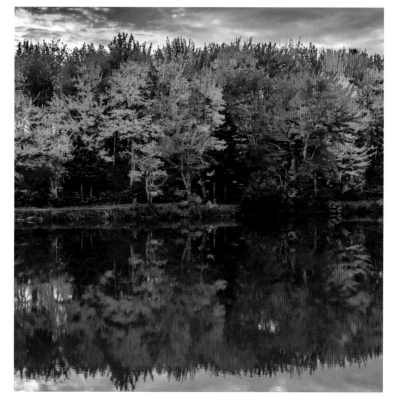

Lunenburg, Nova Scotia
Founded in 1753, Lunenburg gets its German name from King George II, who, before becoming the King of Great Britain, was the Hanoverian Duke of Braunschweig-Lüneburg. The settlement was established in an effort to settle Protestants and displace native Mi'kmaqs and Acadians. With much of its original architecture and layout surviving, Lunenburg is now a UNESCO World Heritage Site.

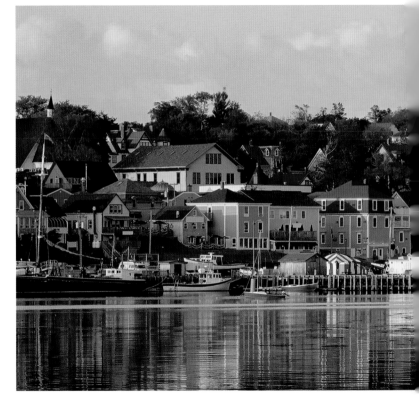

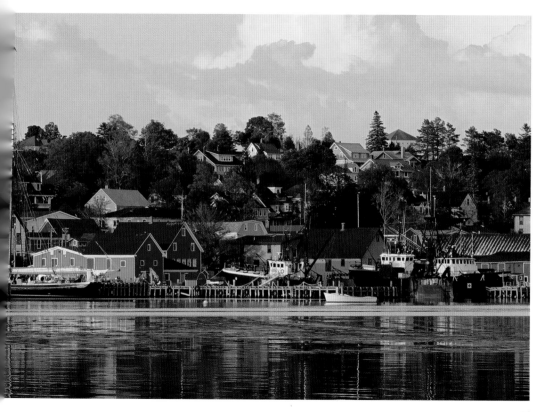

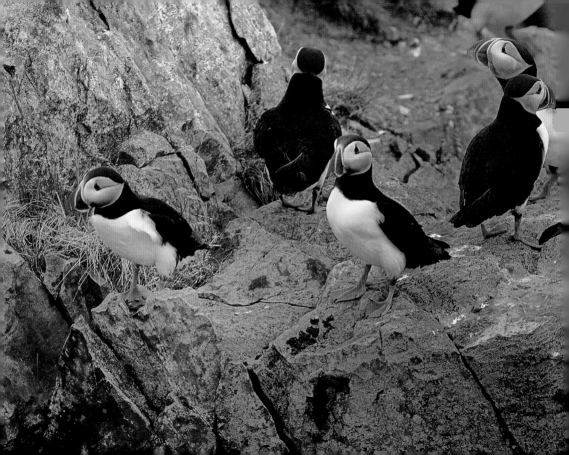

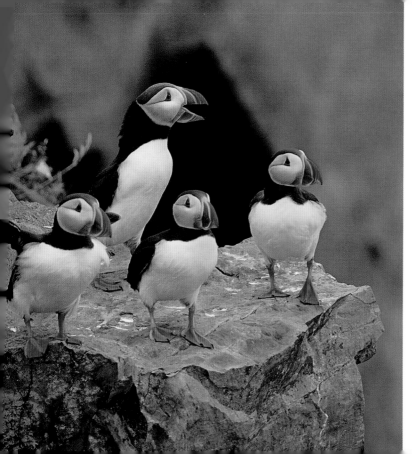

LEFT:

Atlantic puffins, Newfoundland

Puffins breed in huge colonies off coastal cliffs or offshore islands, making Canada's Atlantic region the perfect place for them. They feed on herring and capelin. When they swim, they use a flying technique to move rapidly through the water.

RIGHT:

St John's, Newfoundland
One of the oldest
European settlements
in North America,
Portuguese, Spanish,
French and English
fishermen began coming
to this area in the early
16th century to fish cod. A
permanent settlement was
established by the English
in the 17th century.

The Dutch and French
both fought the English
for St John's. In 1762, the
final battle of the Seven
Years' War (French and
Indian War) was fought
between the French and
the British at Signal Hill in
St John's.

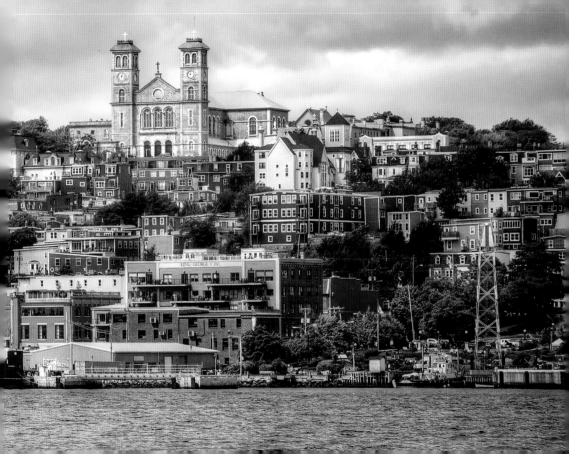

RIGHT:

Inuksuk, St John's, Newfoundland
Inuksuks are manmade stone monuments that 'act in the capacity of a human'. They are made by the Inuit and other Arctic peoples and are found across Canada, Alaska and Greenland.

OPPOSITE:

St John's, Newfoundland
With its steep maze of residential streets, St John's is often compared to San Francisco. It was officially incorporated as a city in 1888 and, as of 2017, has just under 220,000 residents.

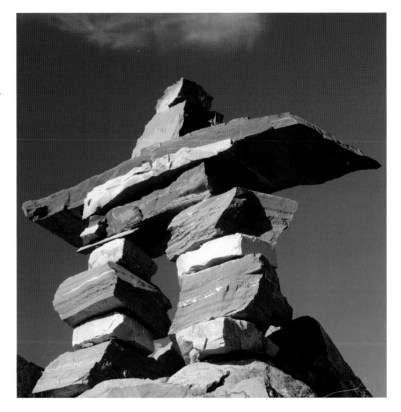

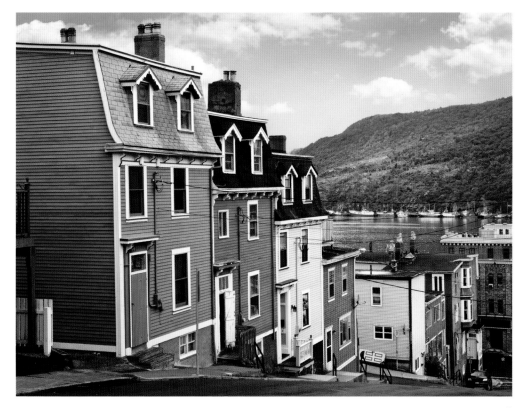

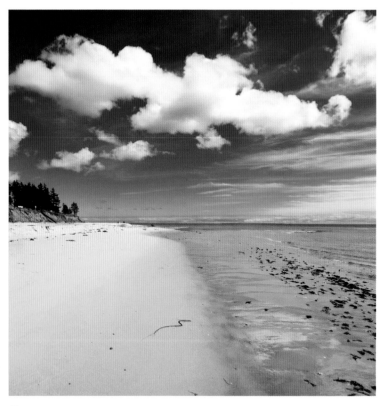

LEFT:
Beach, Red Point Provincial Park, Prince Edward Island
Red Point Provincial Park is at the eastern end of Prince Edward Island. The island has 1,100km (684 miles) of beaches where, in summer, water temperatures reach a fairly warm 22°C (72°F).

OPPOSITE:
Orca, Gulf of St Lawrence
Orcas, also known as killer whales, are the largest member of the dolphin family. Like dolphins, they are social, communicative animals that live in pods. They are most often found in British Columbia, Hudson's Bay and, here, the Gulf of St Lawrence.

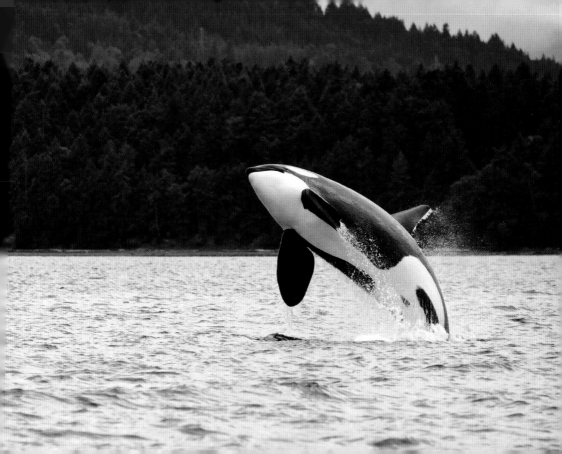

Nain, Nunatsiavut, Labrador
Nain, or Naina, is the northernmost permanent settlement in Newfoundland and Labrador. It was established in 1771 by Moravian missionaries, making it one of Labrador's longest-standing European settlements.

Central Canada

Canada's two largest and most populated provinces are Quebec and Ontario. Quebec is the country's largest province in terms of land mass, but its barren north is uninhabitable. The majority of Québécois residents live around the St Lawrence River, the path that the first European settlers used when exploring North America in the 16th and 17th centuries. A primarily French-speaking province, it has two major cities: Montreal, its largest metropolis; and Quebec City, its capital. The province's history, culture, cuisine and sensibility often give it a European vibe.

Toronto, in Ontario, is Canada's largest city; the population of Toronto's and Montreal's greater metropolitan areas accounts for 62 per cent of all Canadian residents. Almost 40 per cent of the Canadian population live in Ontario and more immigrants settle there than in any other province. The province is also home to the country's capital, Ottawa, which has a large French population.

OPPOSITE:
Algonquin Provincial Park, Ontario
Established in 1893, Algonquin Provincial Park is the oldest provincial park in Canada. Along with thousands of lakes, more than 1200km (746 miles) of streams and rivers run through it.

Algonquin Provincial Park, Ontario
Considered part of the border between the north and south of Ontario, and so between northern coniferous forests and southern deciduous forests, Algonquin Provincial Park supports a huge diversity of animal and plant species. Animals found there include moose, white-tailed deer, beavers, red foxes and Eastern wolves.

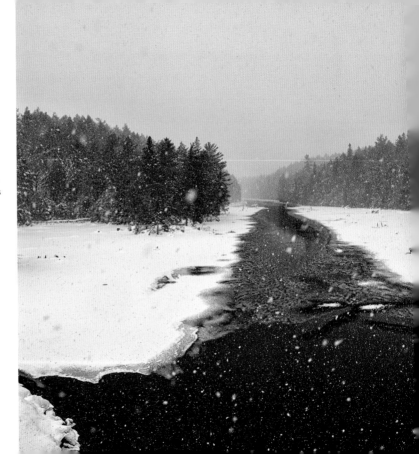

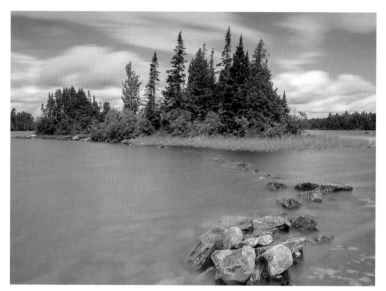

ABOVE:

Algonquin Provincial Park, Ontario

In spring and summer, canoe camping is a popular
activity in the park. Visitors are welcome to canoe to
islands where they can set up camp. Some campsites are
only accessible by canoe in the spring and summer, and
by snowshoe in the winter months.

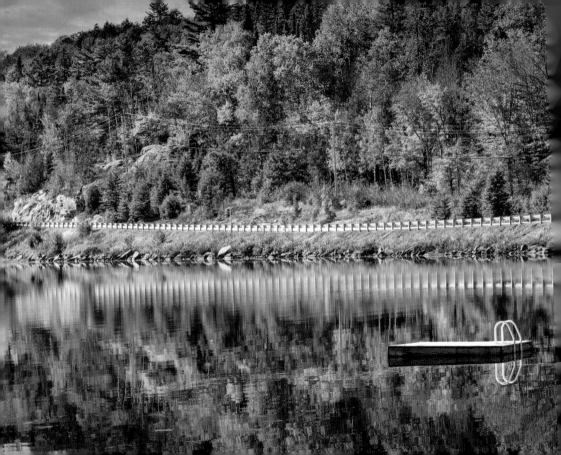

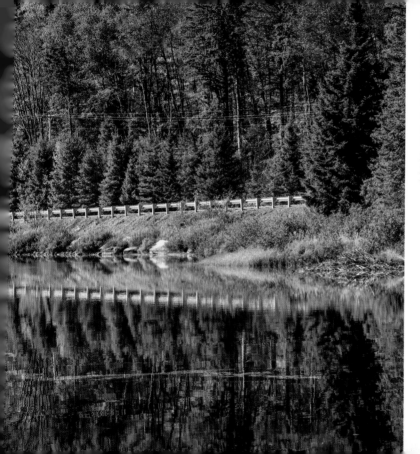

Highway 60, Algonquin Provincial Park, Ontario
Algonquin Provincial
Park has nine major
rivers, all of which are
available to fishermen
who hold fishing licences.
Fishing is one of the most
popular activities in the
park, and the lakes have
trout, bass and pike.

Black Bear, Algonquin Provincial Park, Ontario

Despite their name, American black bears (*Ursus americanus*) show a great deal of colour variation, with coats ranging from white to light brown, dark brown to jet black.

Burlington Canal Lift Bridge, Hamilton, Ontario

Between 1826 and 1952, six bridges were built across the Burlington Canal, which connects Hamilton Harbour and Lake Ontario. The first few wooden bridges were demolished by severe storms. The last was torn down to accommodate the current vertical lift bridge, which carries a road across the canal.

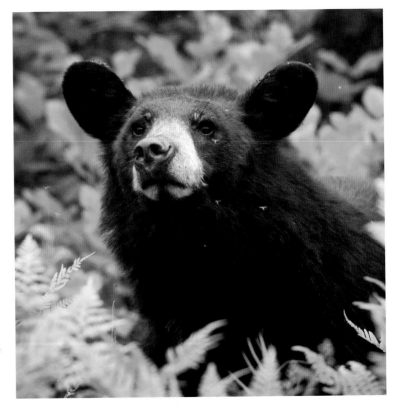

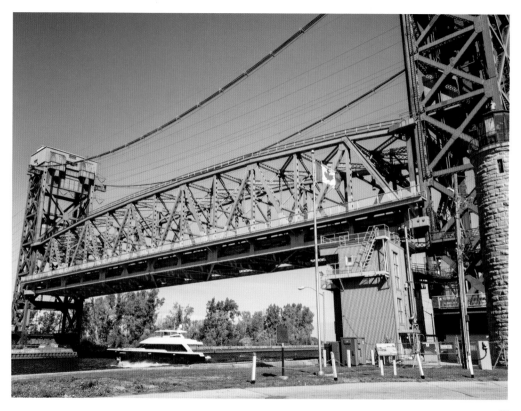

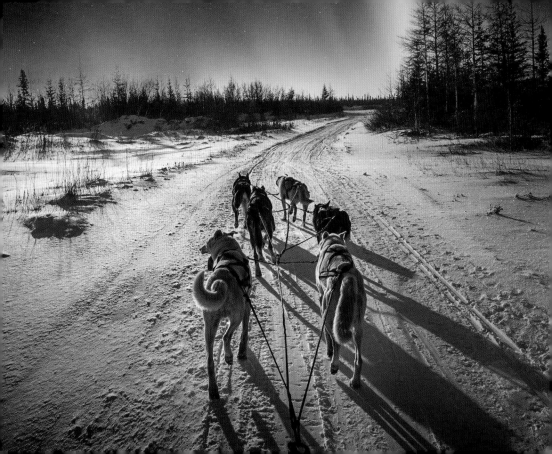

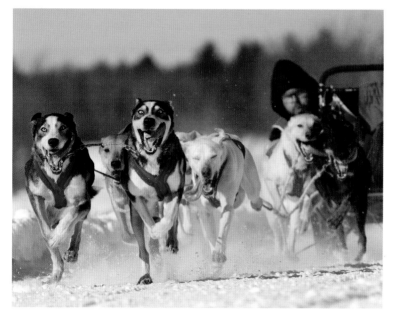

Dog sledding race, Lanaudiere, Quebec
Dog sled races can range between distances of 6.5km (4 miles) or more than 483km (300 miles). Stronger dogs are placed near the sled, but faster dogs who will respond to the musher's commands lead the pack.

OPPOSITE:
Huskies, Ontario
Sled dog racing – with six huskies and one musher (driver) on skis – is a competitive sport popular in Canada's Arctic regions. The green light in the sky is the *Aurora borealis*, or Northern Lights, which is caused by electrically charged particles from the Sun colliding with gaseous particles in the Earth's atmosphere.

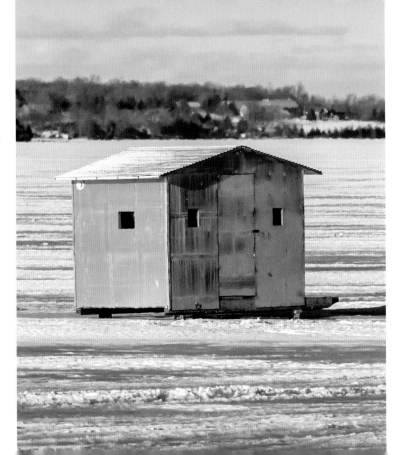

RIGHT:

Ice fishing hut, Scugog Lake, Ontario

Ice fishing huts are seen on many lakes in Quebec and Ontario in the winter. They provide relief and shelter during long days fishing on the ice when the weather is bitter.

OPPOSITE:

Fishing hut, Anse à Benjamin, La Baie, Saguenay, Quebec

Ice huts can be either portable or permanent, and are typically dragged onto the ice using a snowmobile. In Canada, ice fishing is seen as a social activity and huts can be rented at different times throughout the day or for longer.

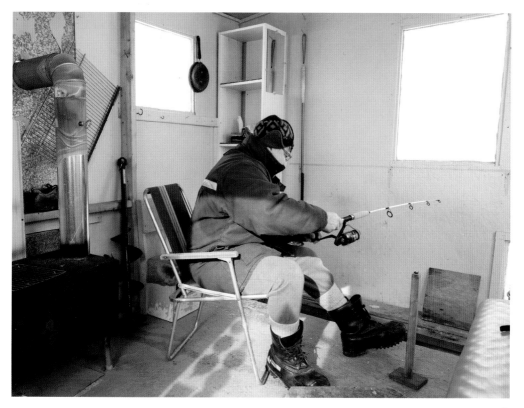

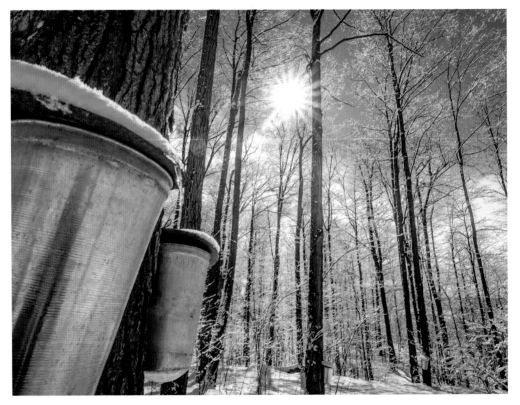

Making maple syrup, Quebec

Maple sap is collected by drilling a hole into trees, inserting a kind of tap called a spile, and allowing the sap to drain into buckets. It is then boiled. The syrup is most often used in small quantities in sweet dishes such as pancakes. The creation and distribution of maple syrup is a highly regulated process and a huge Canadian industry.

LEFT:

Near Port Stanley, Lake Erie, Ontario
Straddling Canada and the United States, Lake Erie is the fourth largest of Canada's five great lakes and the 11th largest lake globally. The name Erie is shortened from an Iroquoian name meaning 'long tail'. The area is known as the thunderstorm capital of Canada, with enormous lightning displays.

Mounties, Ottawa, Ontario

The Royal Canadian Mounted Police (RCMP) is the federal and national police force of Canada. They are internally known as The Force and colloquially known as Mounties. The RCMP acts as the provincial police for all provinces except the two most populous ones: Quebec and Ontario.

The RCMP's Musical Ride, pictured here, is a huge tour that travels across Canada from springtime to autumn, raising money for charity and non-profit organizations.

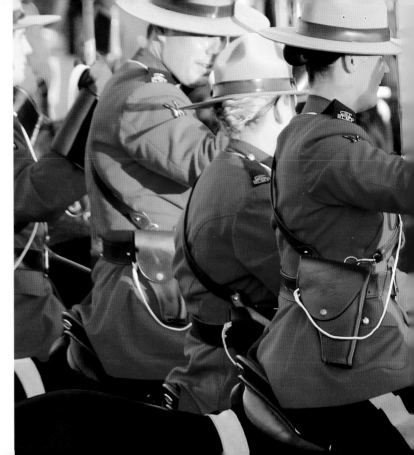

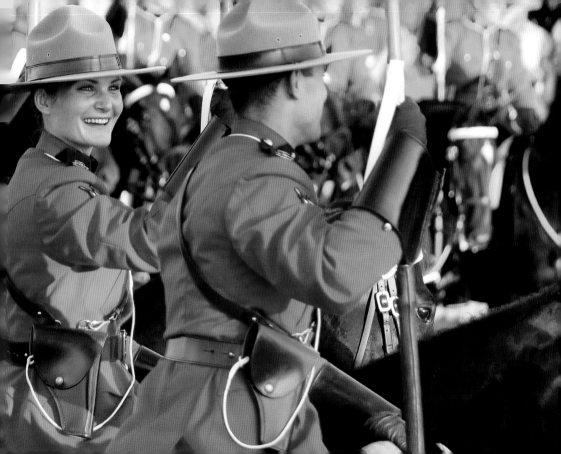

Absolute World condominium towers, Mississauga, Ontario

Nicknamed the Marilyn Monroe towers because of their likeness to the star's curvaceous figure, these two towers are residential condominiums. The larger of the two towers twists 209 degrees from the base to the top.

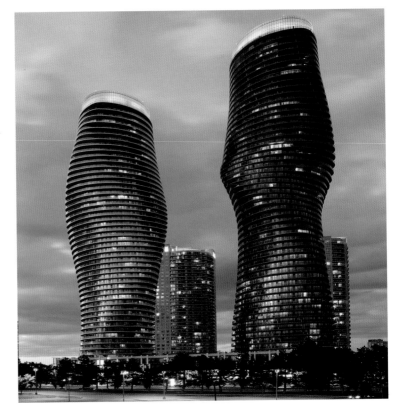

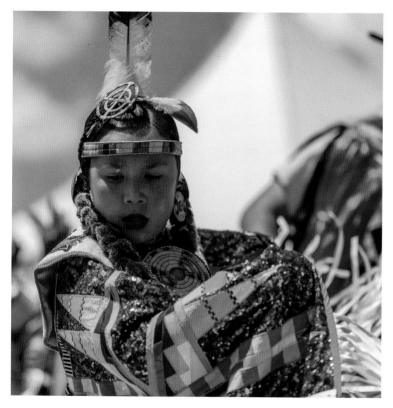

LEFT:

**Ottawa Summer Solstice
Indigenous Festival,
Ottawa, Ontario**
The Ottawa Summer
Solstice Indigenous
Festival, held annually
around 21 June, honours
the contributions that
the Inuit, First Nations
and Métis (those who
trace their descent to
both First Nations and
the very early European
settlers) communities have
made to Canada. The
festival coincides with the
designation of 21 June
as Canada's National
Indigenous Peoples Day,
and is open to everyone.

**Montreal Botanical
Garden, Montreal,
Quebec**

The Jardin botanique
de Montréal is widely
recognized as one of the
world's best botanical
gardens. It spreads over
75 hectares (190 acres)
and has more than
22,000 plant species
and 10 exhibition
greenhouses. The gardens
were established in the
1920s by botany teacher
and Christian Brother
Marie-Victorin and
horticulturalist Henry
Teuscher. The exhibition
greenhouses were opened
in 1956.

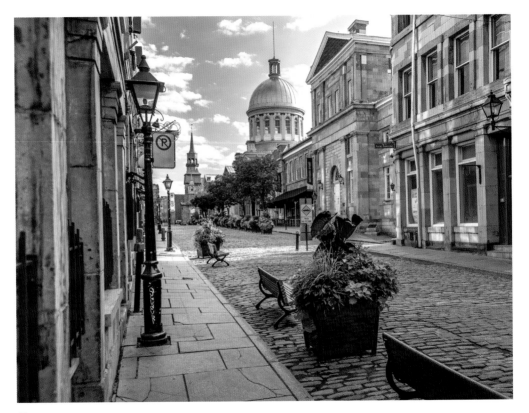

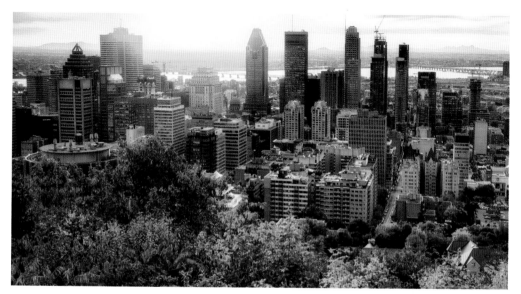

Old Montreal, Quebec

Opened in 1847, Bonsecours Market (the domed building) was one of Montreal's central markets for small vendors until it closed in 1963. Originally slated for demolition, it was saved and restored. Today it is home to cafés, restaurants and boutiques. Beyond it is Notre-Dame-de-Bon-Secours Chapel, which was built in 1771.

ABOVE:

Montreal, Quebec

Half of the population of Montreal speaks French as their first language (French and English are the two official languages of Canada). After Paris, Montreal is the second largest predominantly French-speaking city in the world.

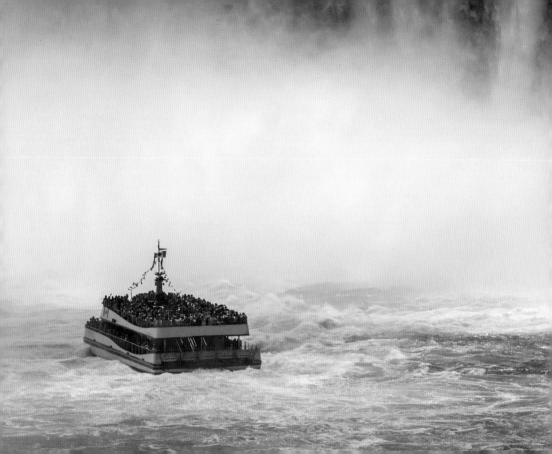

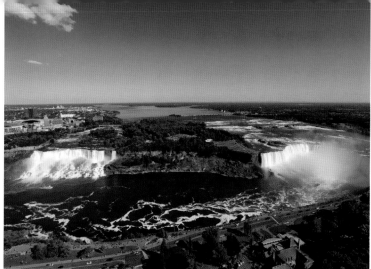

LEFT AND ABOVE:
Niagara Falls, Ontario
Niagara Falls, a group of three waterfalls, sits between the Canadian province of Ontario and the US state of New York. The falls have the highest flow rate of any waterfall in North America with a vertical drop of more than 50m (164ft). During peak hours, more than 170,000 cubic metres (six million cubic feet) of water goes over the crests of the falls every minute.

Maid of the Mist (left) is a tourist boat that takes travellers right underneath Niagara Falls. It actually starts and ends on the American side of the falls, stopping briefly in Ontario. The 'mist' part of the tour happens when the boat sails into a dense spray inside the curve of Horseshoe Falls.

71

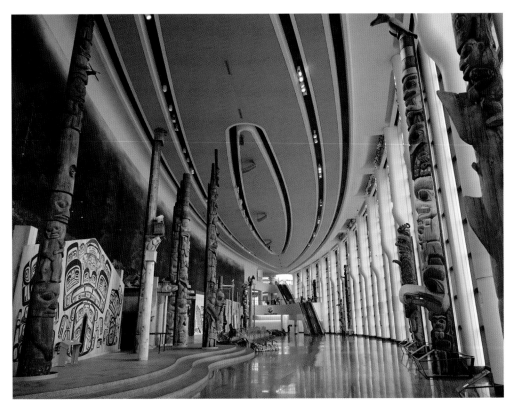

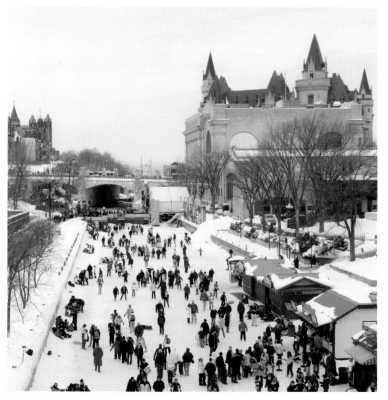

Great Hall, Canadian Museum of History, Gatineau, Quebec

The Canadian Museum of History's Great Hall houses art which has been contributed by or created by indigenous artists. The museum's intention is to collect and preserve art that showcases the country's culture and history. It specializes in ethnology, archaeology, folk culture and travel.

LEFT:

Rideau Canal, Ottawa, Ontario

In winter, the Rideau Canal, which connects Ottawa to Lake Ontario and the St Lawrence River, becomes one of the longest continuous outdoor skating rinks in the country.

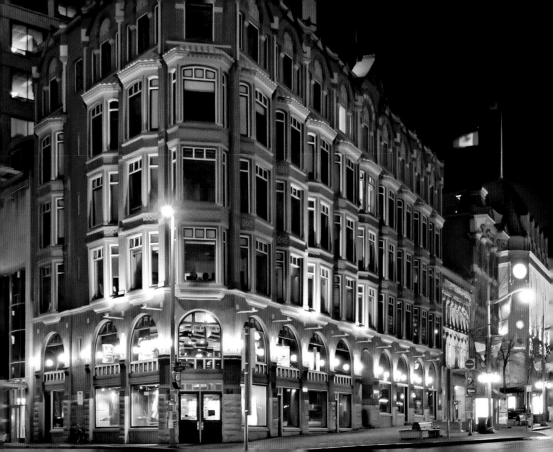

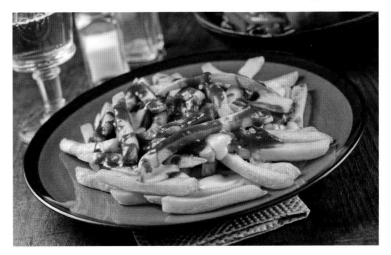

**Central Chambers,
Ottawa, Ontario**
An example of Queen
Anne Revival architecture,
Central Chambers is an
1890s office building.
The clock tower of the
Canadian Parliament
Buildings can be seen in
the background.

ABOVE:
Poutine
Poutine originated in
Quebec. It has a base of
chips and is topped with
gravy and cheese curds.
It has grown from mere
'hockey arena food' to a
popular dish that can be
made with a variety of

cheeses and different kinds
of gravy. This has made
poutine more 'upscale'.
The cheese and gravy are
added right before serving
to stop the chips from
becoming soggy.

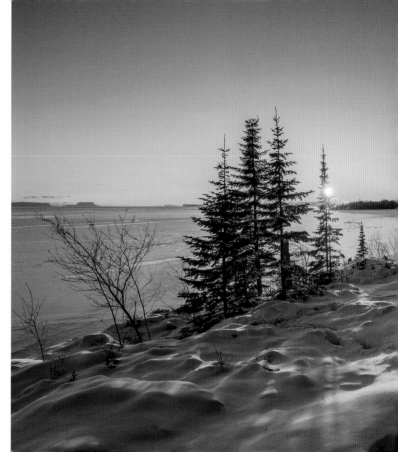

RIGHT:

Near Thunder Bay, Lake Superior, Ontario
In the 19th century, Thunder Bay became an important port linking western Canada and the shipping of grain from the prairies through the Great Lakes and the St Lawrence Seaway to the east coast. The city is the country's most westerly one on the Great Lakes.

OPPOSITE:

Lake lodges, Ontario
Lodges on lakes in Ontario – such as at Georgian Bay on Lake Huron – are highly popular holiday destinations. Activities offered include boating, guided cruises, and canoe and kayak adventures.

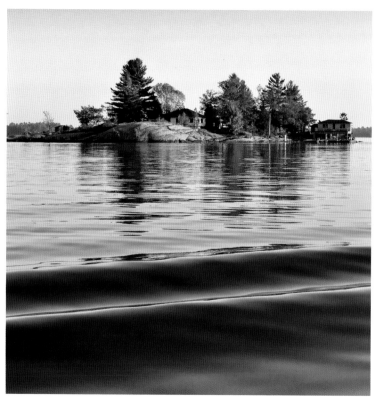

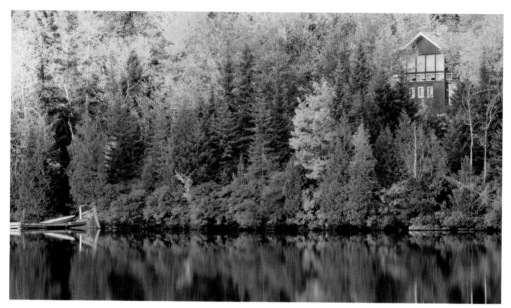

Autumn, Quebec
Enjoying Quebec's
autumn colours from
mid-September to mid-
October is popular both
with locals and visitors.

The changing colours are
caused by the decrease in
light when the days begin
to get shorter. The sugar
in the sap brings out the
striking reds.

**Place d'Armes and
Notre-Dame Basilica,
Montreal, Quebec**
The Maisonneuve
Monument on the left
is a late 19th century
celebration of Paul de
Chomedey, founder of the
city of Montreal in the
mid-17th century.

On the right (and
opposite) is Notre-
Dame Basilica. The
original church was
built in 1672, but by
1824 its congregation
had outgrown its size
and a new building was
commissioned. The
existing structure was
completed in 1843.

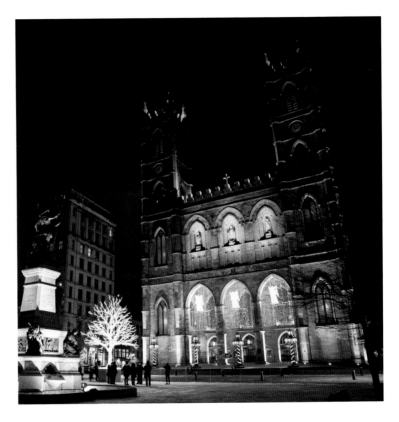

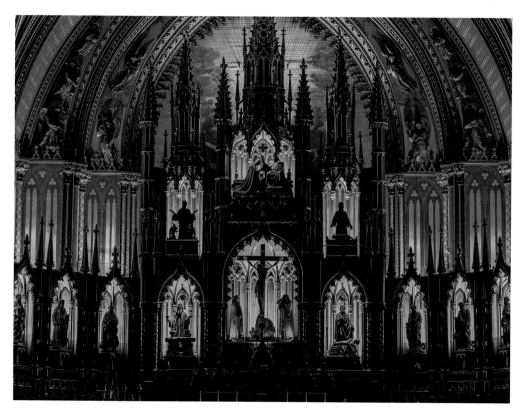

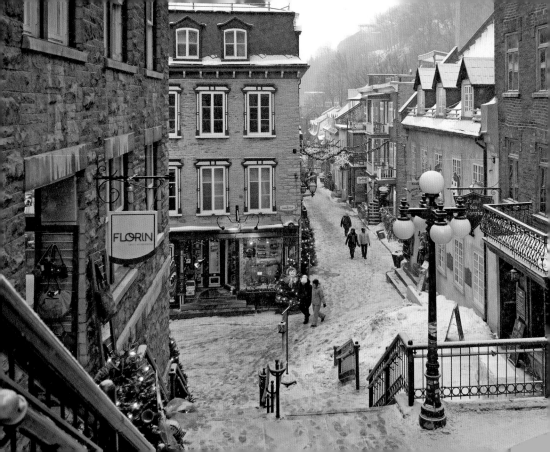

OPPOSITE:

Rue de Petit Champlain, Quebec City, Quebec

Rue de Petit Champlain was named after Samuel de Champlain, who founded Quebec City in 1608. The Breakneck Stairs, of which we can see the lowest, more gentle steps, were built in 1635. Their name comes from their steepness.

RIGHT:

Place-Royale, Old Quebec City, Quebec

Place-Royale is considered the historic heart of Quebec, and is home to many historic buildings.

The mural painted on the side of the house located at number 102 is a trompe-l'œil representing the history of the district.

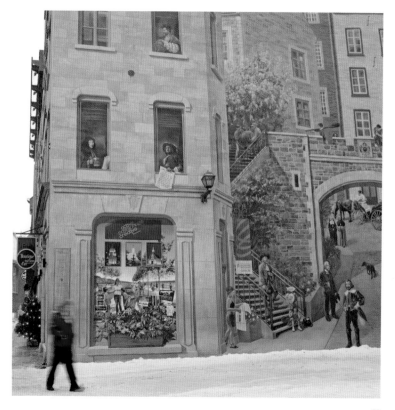

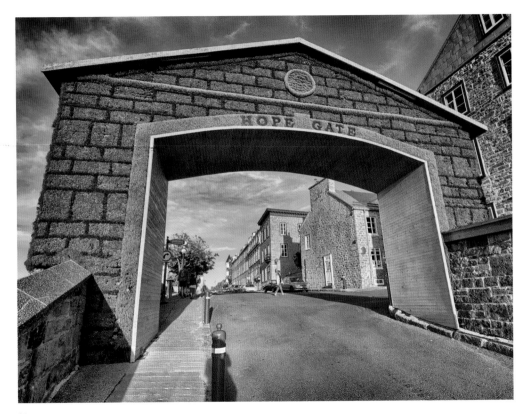

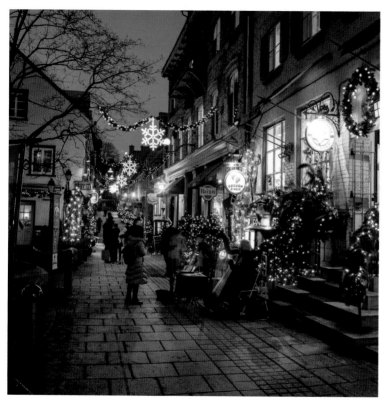

OPPOSITE:

'Hope Gate', Quebec City, Quebec

The original Hope Gate was constructed in 1786 but pulled down in 1873 (it was no longer needed). During the war of 1812 between the United States and Great Britain, Hope Gate was one of only two places where people could enter the city. This gate made of plants appeared as a temporary structure in 2008.

LEFT:

Rue du Petit Champlain, Basse-Ville, Quebec City, Quebec

Founded in the early 17th century, it has been claimed that the Petit Champlain quarter is the oldest commercial area in North America.

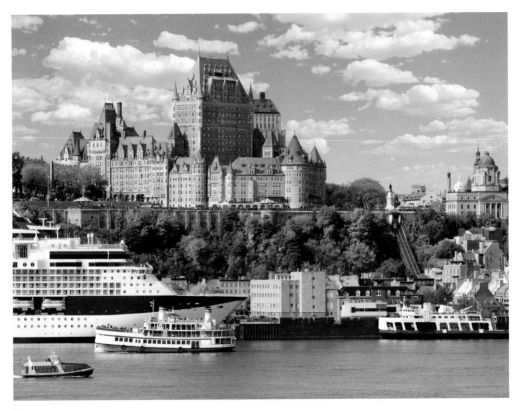

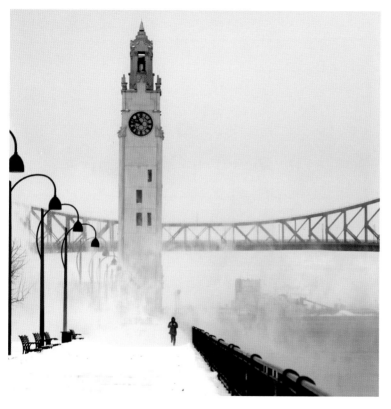

OPPOSITE:

Fairmont Le Château Frontenac Hotel and the St Lawrence River, Quebec City, Quebec
Built by the Pacific Railway Company, the Fairmont Le Château Frontenac Hotel is a Quebec City landmark and offers a beautiful view of the St Lawrence River. It's situated in Old Quebec's Upper Town.

LEFT:

The Montreal Clock Tower, Old Montreal, Quebec
Completed in 1921, the Montreal Clock Tower was built as a memorial to the Canadian sailors who died during World War I. Behind it can be seen the Jacques Cartier Bridge crossing the St Lawrence River.

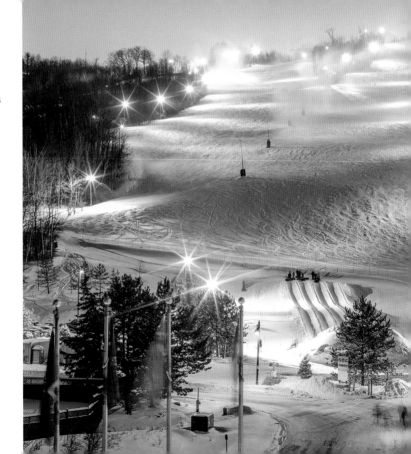

RIGHT:
**Blue Mountain Village
Ski Resort, Ontario**
One of the busiest ski
resorts in Canada, Blue
Mountain Village boasts
147 hectares (364 acres)
of skiable area and has
42 runs.

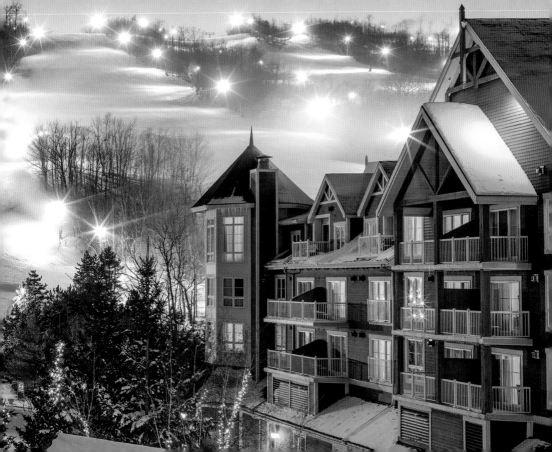

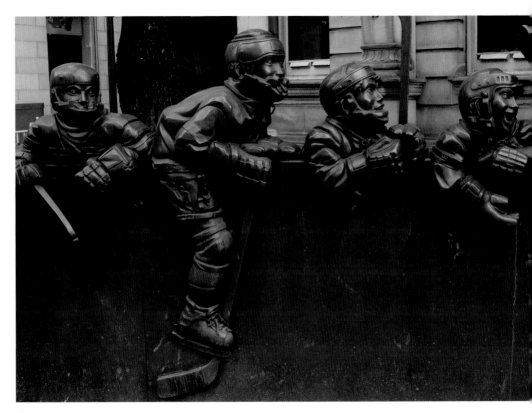

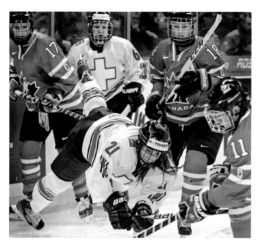

Our Game, **Toronto, Ontario**
Edie Parker's bronze sculpture, unveiled in 1993, stands outside Canada's Hockey Hall of Fame in Toronto.

ABOVE:

Women's Ice Hockey World Championship 2013, Ottawa, Ontario
Canada plays host to many International Ice Hockey Federation tournaments. In this game, played during the 2013 IIHF World Championship, Canada defeated Switzerland, but eventually lost in the final to the US.

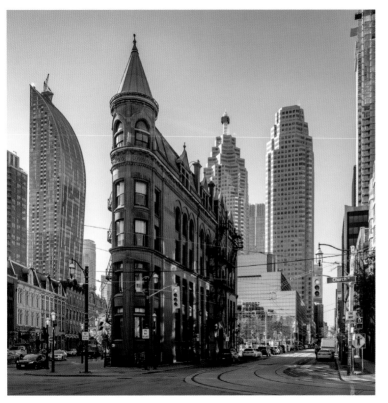

**Gooderham Building,
Toronto, Ontario**
Built at the convergence
of several streets at the
St Lawrence Market in
downtown Toronto, the
Gooderham Building,
known as the 'Flatiron
Building' due to its
design, is a city landmark
constructed in 1892.

OPPOSITE:

Toronto, Ontario
A view of the skyline
looking north from
downtown. With almost
three million residents,
Toronto is Canada's most
populous city.

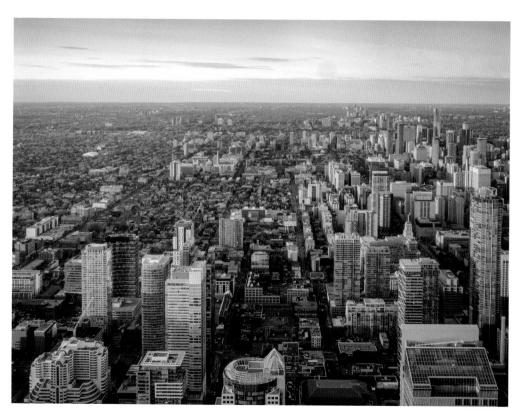

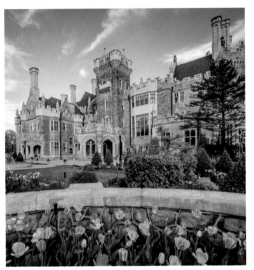

ABOVE AND RIGHT:

Casa Loma, Toronto, Ontario

Casa Loma (Spanish for 'hill house') was constructed between 1911 and 1914, and is a historic house museum and gardens that can be rented for weddings and private events.

OPPOSITE:

CN Tower, Toronto, Ontario

From its construction in 1975 until 2007, the CN Tower was the world's tallest building. Today it ranks as ninth tallest. A communications tower, the 'CN' stands for Canadian National, the railway company that built the structure on the site of a former railway switching yard near Toronto's waterfront.

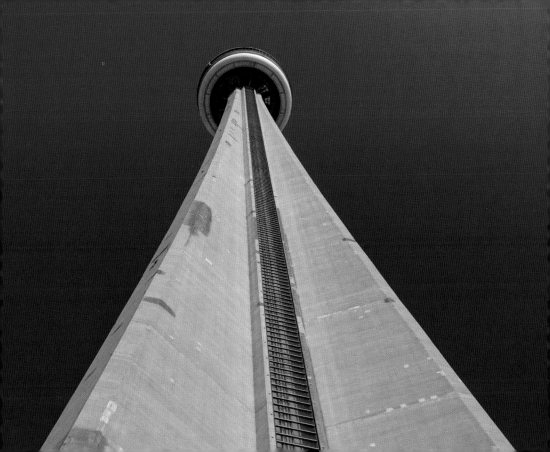

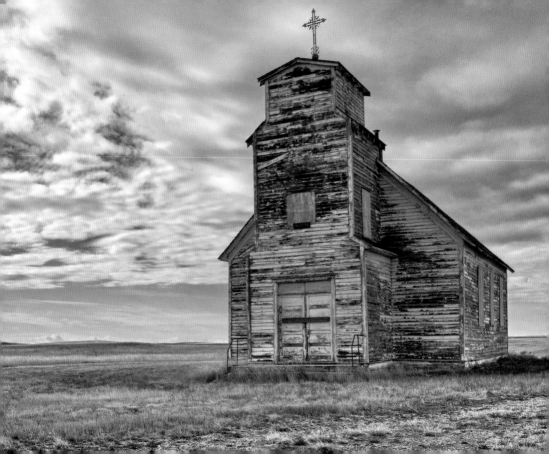

The Prairie Provinces

Moving east to west, Manitoba, Saskatchewan and Alberta are the provinces in western Canada known as the Prairies. Apart from mining, the fertile land of the Prairies means that many residents still live in smaller towns and communities, making their living from farming. There are nearly seven million people living across these provinces.

In the 1950s, Alberta underwent an oil boom, making it the richest province in the country, and today oil remains its dominant industry. The province is fringed on the west by the peaks of the Rocky Mountains, a dramatic contrast to the hundreds of miles of prairies and low-lying forests stretching out to the east.

Saskatchewan's exports include uranium, oil, potash, and – its best known product – wheat. Winnipeg, the capital city of Manitoba, is not only the coldest city in southern Canada but one of the five coldest cities in the world. The Canadian Museum For Human Rights, the largest human rights museum in the world – and most disability-accessible public space in Canada – opened in Winnipeg in 2014.

OPPOSITE:
St Anthony's Church, near Etzikom, Alberta
A little church on the prairie, St Anthony's was built in 1911 and closed in 1991.

**Cypress Hills
Interprovincial Park,
Alberta-Saskatchewan**
The Cypress Hills
Interprovincial Park
straddles the Alberta-
Saskatchewan boundary.
With a high elevation and
lacking light pollution, the
park is an excellent place
for stargazing.

**Combine harvesters,
Saskatchewan**
Wheat that grows in the
Saskatchewan prairies is
known to be of the highest
quality and is exported
worldwide.

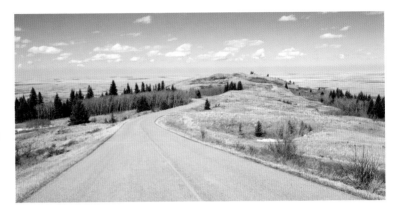

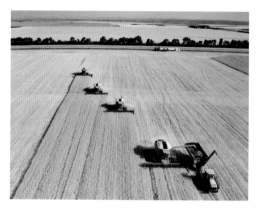

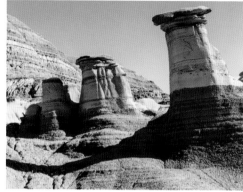

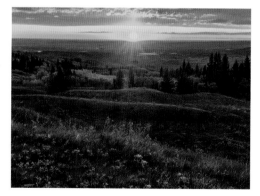

TOP RIGHT:

Hoodoos, Drumheller Badlands, Alberta
These hoodoos are stacks of sandstone and darker mudstone, standing on shale bases and topped by large stones. They have been exposed by natural erosion caused by water and wind. This erosion of the sedimentary rock has also revealed an immense deposit of dinosaur fossils, now housed in Drumheller's Royal Tyrrell Museum.

BOTTOM RIGHT:

Dawn over Cypress Hills, Alberta-Saskatchewan
The Cypress Hills support extensive forest and grassland. Cougars and cattle have also made the hills their home.

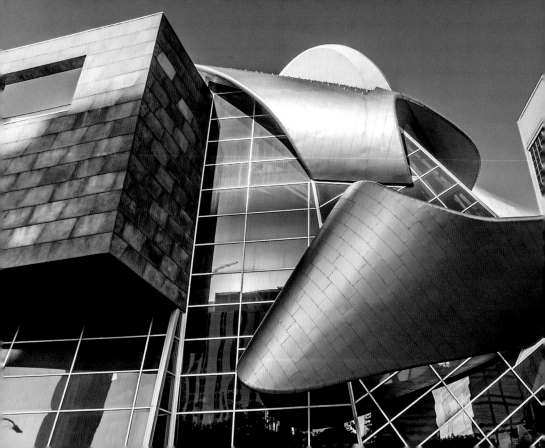

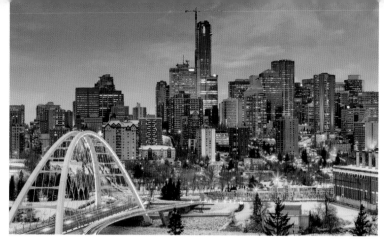

LEFT:

Art Gallery of Alberta, Edmonton, Alberta
The Art Gallery of Alberta (formerly the Edmonton Art Gallery) was founded in 1924. This larger building, designed by Randall Stout, was opened in 2010. The winding steel ribbon echoes both the turns in the North Saskatchewan River and the shapes of the *Aurora borealis*.

ABOVE:

Waterdale Bridge, Edmonton, Alberta
Opened in 2017, the Waterdale Bridge straddles the North Saskatchewan River. The capital city of Alberta, Edmonton is the second largest city in the province and the fifth largest municipality in the country. Among its attractions is Fort Edmonton Park, Canada's largest living history museum. Fort Edmonton itself was established as a major trading post by the Hudson's Bay Company in the late 18th century.

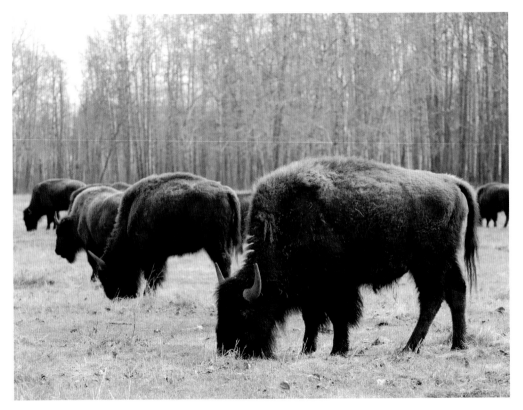

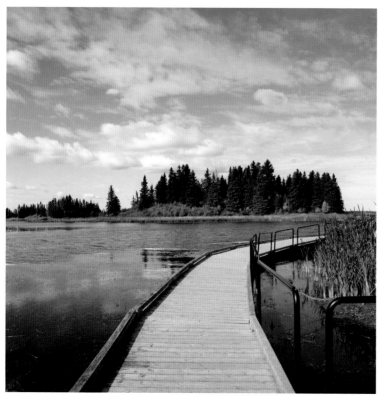

Wild bison, Elk Island National Park, Alberta
Bison are the largest surviving terrestrial animals in North America and Europe. American bison (*Bison bison*) are commonly referred to as buffalo, but are actually only a distant cousin of the buffalo genus.

LEFT:
Astotin Lake, Elk Island National Park, Alberta
Elk Island National Park is located at the edge of a coniferous forest. Following the overhunting of beaver and ungulates in the 19th century, an elk sanctuary was established here in the first years of the 20th century. Today, bison, moose, mule deer, elk and beaver can be found in the park.

RIGHT:

Festival du Voyageur, Winnipeg, Manitoba

Festival du Voyageur, Canada's largest winter festival, is held every February in St Boniface, the French-speaking neighbourhood of Winnipeg.

February is the coldest month of the year for Winnipeg, with the temperature sometimes dropping below -40°C (-40°F).

RIGHT:

Little Manitou Lake, Saskatchewan

There's no fishing in Little Manitou Lake because of its high salt content, but that salt allows visitors in summer to float easily in the water. In the 19th century, the minerals in the waters were believed to cure people of smallpox, and those who were ill were submerged in the water.

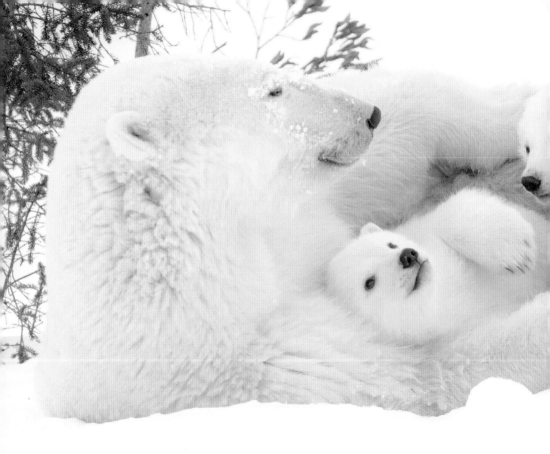

Polar bear mother and cubs,
Wapusk National Park, Manitoba
The setting might be serene, but beware: polar bears can be utterly ferocious and are capable of taking down a human being within seconds, especially when protecting their cubs. A guided tour is the best way to see the bears.

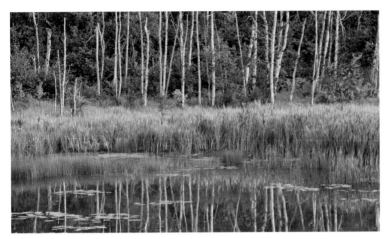

BOTH PHOTOGRAPHS:

Prince Albert National Park, Saskatchewan
Heavily forested in the transition between the northern boreal (coniferous) zone and more southerly aspen parkland, Prince Albert National Park is noted for its three very large lakes – Waskesiu, Kingsmere and Crean – which hold strong fish populations of Northern pike, walleye, suckers and lake whitefish. Lacking is lake trout, which was overfished in the early 20th century and, although now protected, has yet to recover to its former numbers.

The Waskesiu River (right) is today a popular spot for paddling in kayaks. *Waskesiu* is a Cree word for elk or red deer.

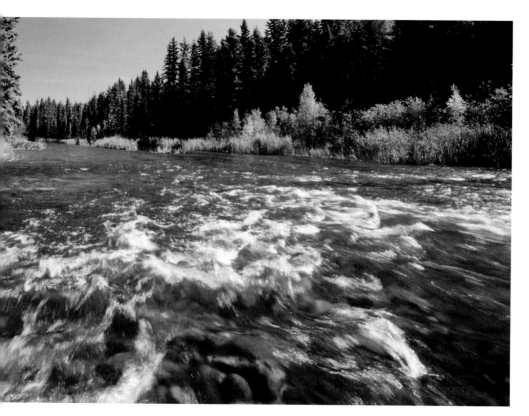

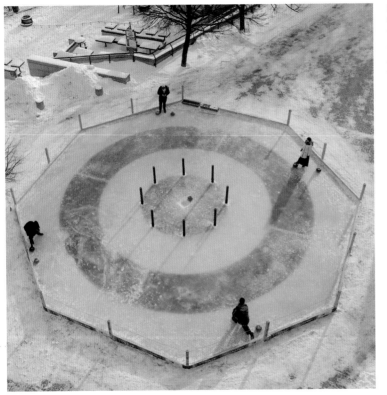

LEFT:

Crokicurl, The Forks, Winnipeg, Manitoba
Crokicurl is a combination of the winter sport curling and the boardgame Crokinole. Invented in Winnipeg, it is played in Calgary, Saskatoon, Regina and other cities.

OPPOSITE:

Canadian Museum for Human Rights, Winnipeg, Manitoba
Opened in 2014, the Canadian Museum For Human Rights is Canada's only national museum outside the capital region of Ottawa.

The museum was designed with the needs of every visitor in mind and it continually employs and supports people with disabilities.

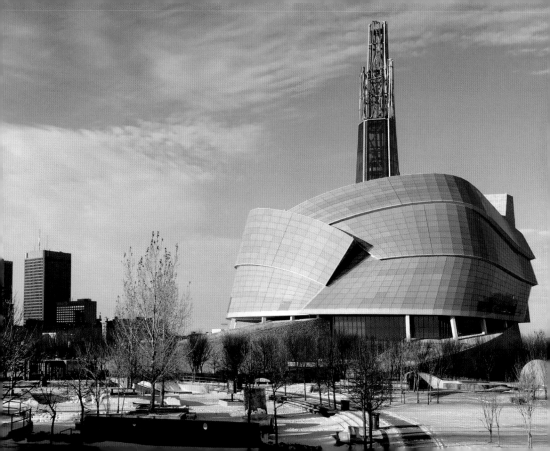

Winnipeg, Manitoba
Built on the confluence of
the Red and Assiniboine
rivers, Winnipeg takes its
name from nearby Lake
Winnipeg. The area was
a trading post for First
Nations peoples before
French traders arrived in
the 18th century.

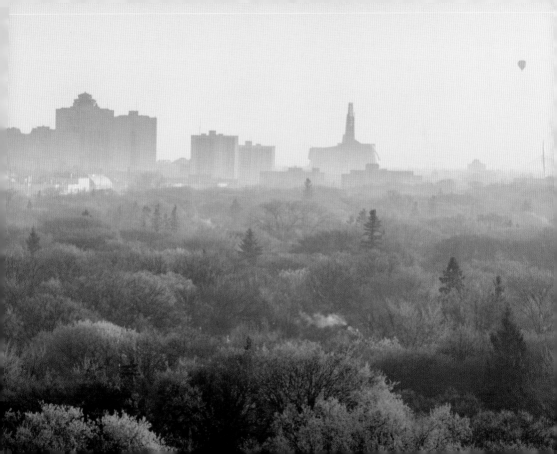

St Boniface Cathedral, Winnipeg, Manitoba
Although dating from 1906, only the façade of the original St Boniface Cathedral remains. Following a fire in 1968, a smaller cathedral was built behind the façade. It serves the Roman Catholic community in French-speaking Manitoba (also called Franco Manitoba).

Exchange District, Winnipeg, Manitoba
The Exchange District has been able to preserve many of Winnipeg's historic buildings. These Chicago-style blocks are now used as apartment buildings and co-working office spaces.

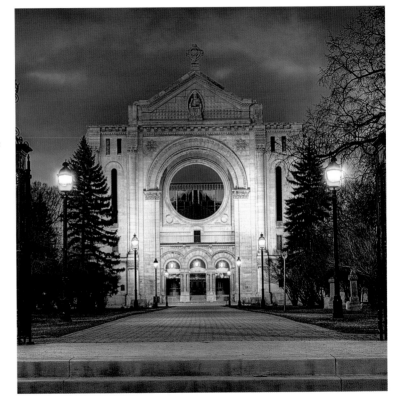

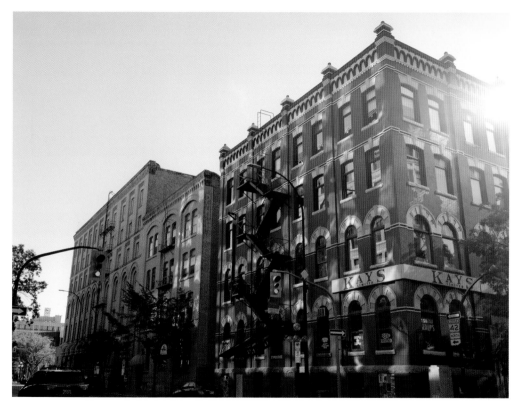

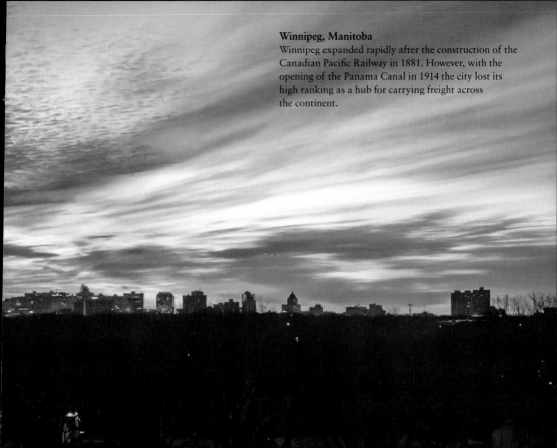

Winnipeg, Manitoba
Winnipeg expanded rapidly after the construction of the
Canadian Pacific Railway in 1881. However, with the
opening of the Panama Canal in 1914 the city lost its
high ranking as a hub for carrying freight across
the continent.

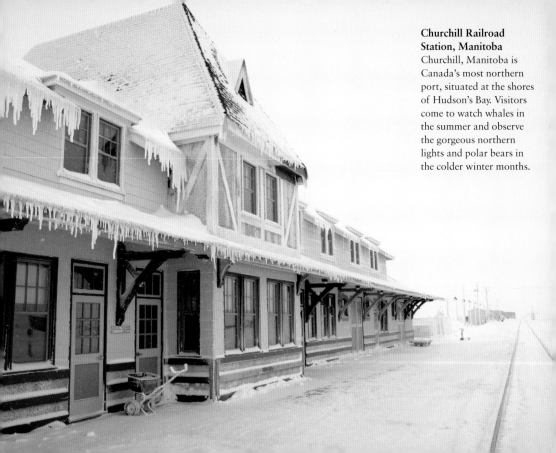

Churchill Railroad Station, Manitoba

Churchill, Manitoba is Canada's most northern port, situated at the shores of Hudson's Bay. Visitors come to watch whales in the summer and observe the gorgeous northern lights and polar bears in the colder winter months.

Arctic safari, Wapusk National Park, Manitoba
An Arctic safari provides an up-close view of polar bears. Wapusk National Park – 45km (28 miles) south of Churchill – can only be accessed by Tundra Buggy (pictured) or helicopter, which helps to preserve the natural beauty of the park.

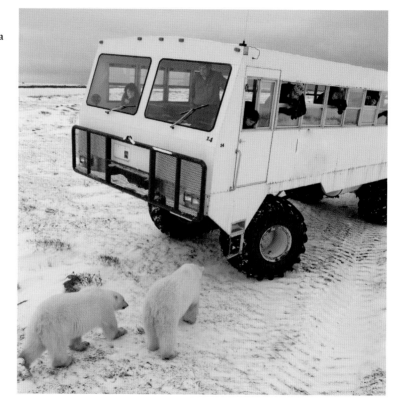

Ice field, Jasper National Park, Alberta
Jasper National Park is known for glaciers, springs, lakes, waterfalls and mountains. On the left of the image is the Athabasca Glacier, the most visited in North America.

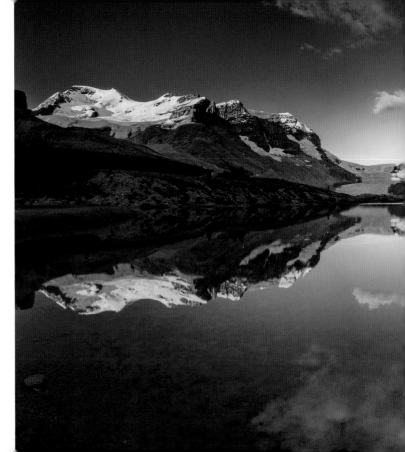

122

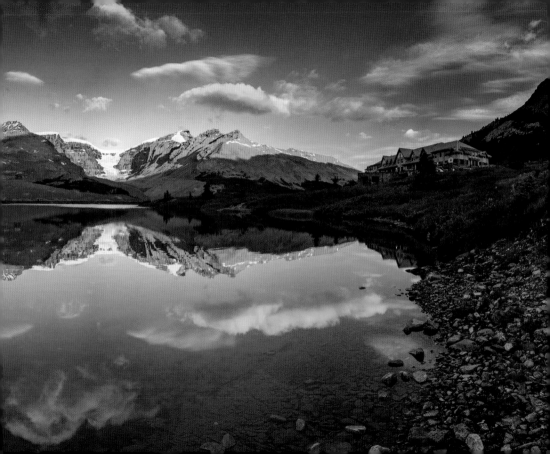

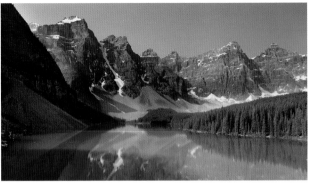

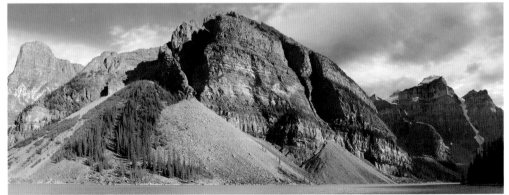

Banff, Alberta
Today Banff is a popular spot for hiking, climbing and skiing, but the area was initially developed around a series of natural hot springs. The town was named after Banff in Scotland, the birthplace of George Stephen, President of the Canadian Pacific Railway, who was one of the three workers who first came across the hot springs in the 1880s.

OPPOSITE, TOP RIGHT AND BOTTOM:
Moraine Lake, Banff National Park, Alberta
Moraine Lake reaches its full crest in mid-June every year, when it reflects a distinct shade of blue. This comes from the refraction of light off the rock flour that the surrounding glaciers deposit there.

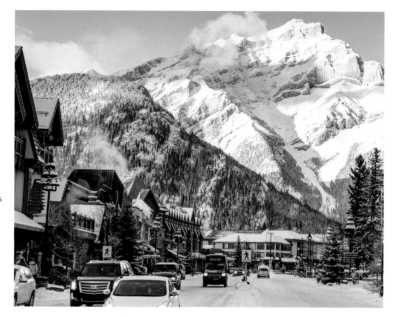

ABOVE:
Banff Avenue, Banff National Park, Alberta
In the 1880s, Banff's springs were promoted as a way of encouraging people to make use of the newly constructed Canadian Pacific Railway. In the background is Cascade Mountain.

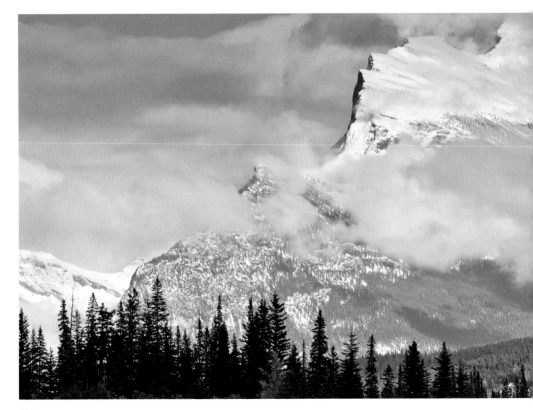

LEFT:

Mount Rundle and Vermillion Lakes, Banff National Park, Alberta
Mount Rundle is one of Canada's most recognizable mountains, and is a difficult climb for even the most experienced hikers. Rundle rock was first quarried on the mountain and is a common stone used in southern Alberta for landscaping.

Ice hockey, Lake Louise, Banff National Park, Alberta
Every year Lake Louise freezes and the lake is prepared for ice-skating. Once the ice is thick enough, the snow is cleared and water is poured on the ice. The water freezes and provides a smooth surface for ice-skating and ice hockey.

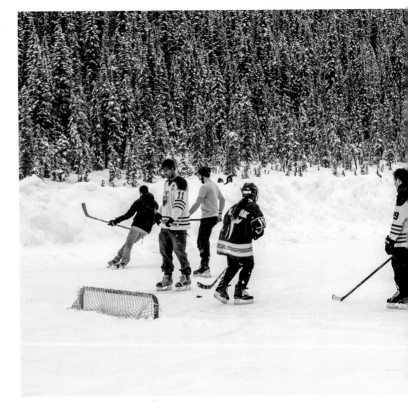

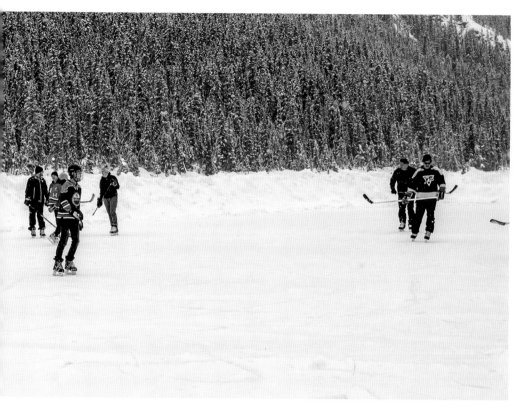

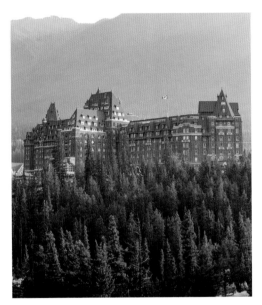

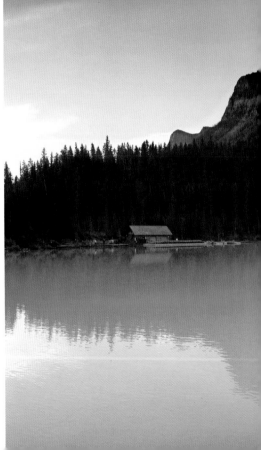

ABOVE:

Fairmont Banff Springs Hotel, Banff, Alberta
Opened in 1888, the Fairmont Banff Springs Hotel was built by the Canadian Pacific Railway and was one of the country's earliest grand railway hotels. The present structure – the original, wooden one having burnt down – was completed in 1928.

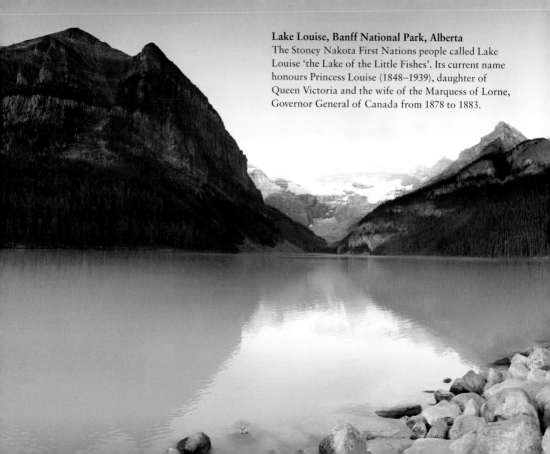

Lake Louise, Banff National Park, Alberta
The Stoney Nakota First Nations people called Lake Louise 'the Lake of the Little Fishes'. Its current name honours Princess Louise (1848–1939), daughter of Queen Victoria and the wife of the Marquess of Lorne, Governor General of Canada from 1878 to 1883.

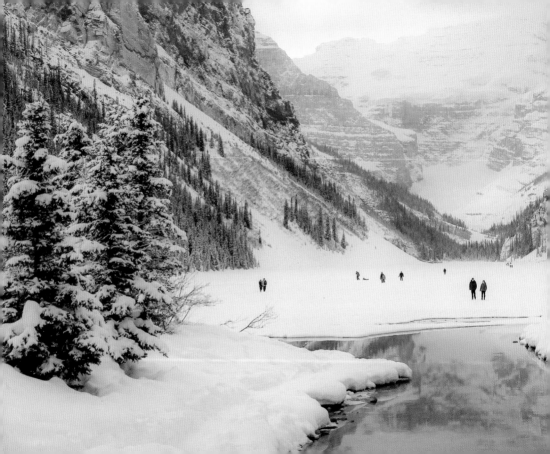

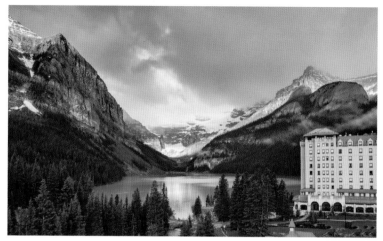

LEFT:

Lake Louise, Banff National Park, Alberta
Fed by a glacier, Lake Louise attracts thousands of
tourists every year, who hike and canoe in the summer
months and skate on the lake in the winter.

ABOVE:

Lake Louise, Banff National Park, Alberta
The Chateau Fairmont Hotel is located on the eastern
shore of Lake Louise. The wing visible in this image was
completed in 2004, but the hotel dates back to 1913.

Wonderland, Bow Tower, Calgary, Alberta
Wonderland, a wire sculpture that stands 12m (39ft) tall, was created by Jaume Plensa. Since 2013, it has been placed outside the Bow Tower.

The Saddledome, Calgary, Alberta
The Scotiabank Saddledome is a multi-use arena built in 1983. As well as being the home arena for Calgary's hockey team, The Flames, it is also a concert venue.

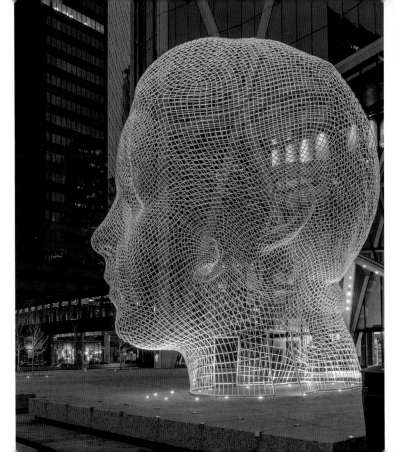

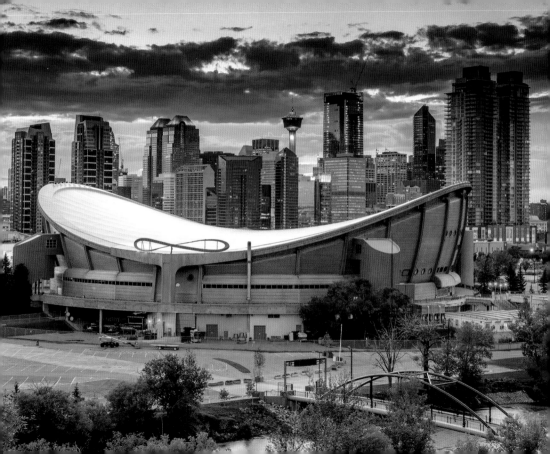

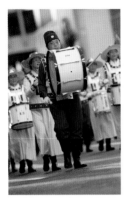

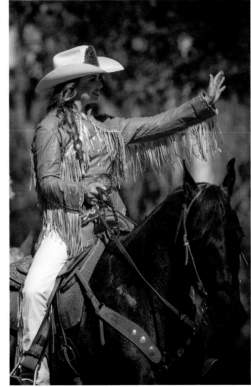

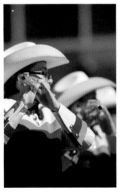

Calgary Stampede, Alberta

The Calgary Stampede features rodeo events, music and dancing, as well as exhibitions of indigenous art and stories. The festival dates back to 1886 and now attracts more than one million people. It has drawn significant criticism from animal rights groups, but since its inception has been an unfailing attraction for the city.

The Stampede's growth reflects the city's own growth following the discovery of oil reserves in the 1950s. Seventy per cent of attendees are Calgary residents.

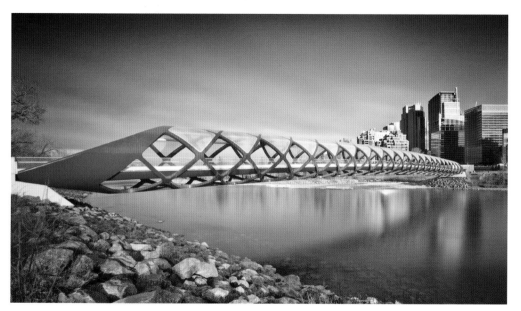

Peace Bridge, Calgary, Alberta
Opened in 2012, the Peace Bridge allows pedestrians
and cyclists easy access between Downtown Calgary, on
the right, and the residential area of Sunnyside across
the Bow River. It is used by 6000 people every day.

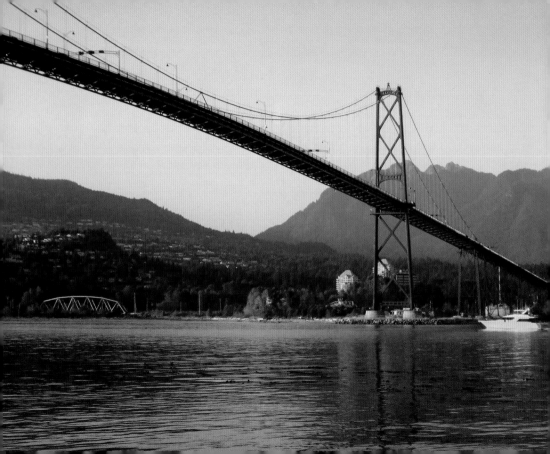

British Columbia

The west coast province of British Columbia consistently ranks as not just one of the best places to live in Canada but in the entire world. Very few other locations in the country have both mountains and oceans, which makes the province a paradise for hikers, bikers, swimmers, sailors, boaters and skiers. The waterfront and mountain views also make the province one of the country's most expensive to live in. There is certainly no shortage of work for wine merchants, vegan chefs and yoga teachers.

On North Vancouver Island, visitors can kayak with seals, sea lions and orcas. The Peak 2 Peak Gondola cable car, which connects Whistler to Blackcomb, is record-breaking for its height and length.

British Columbia is also known for its huge evergreen trees, rivers and deep valleys, as well as eight natural hot springs. Its initial industries were lumber, fishing and minerals, but over the years the focus has shifted to tourism, banking, real estate and software design.

OPPOSITE:
Lions Gate Bridge, Vancouver, British Columbia
Opened in 1938, the Lions Gate Bridge crosses the first narrows of Burrard Inlet and connects Vancouver to the city's North Shore municipalities. 'Lions Gate' refers to The Lions, a pair of mountain peaks on the north side.

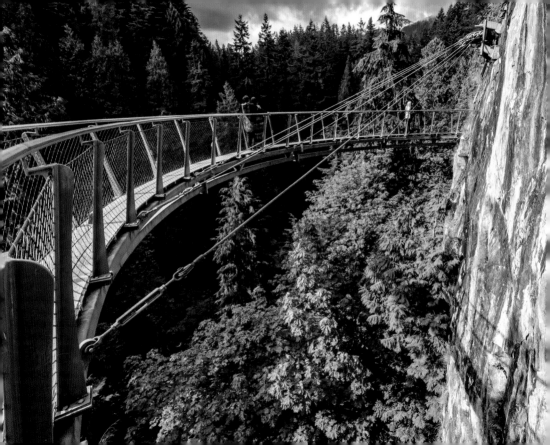

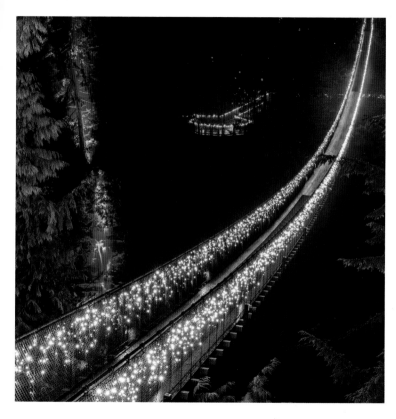

**Capilano Cliff Walk
Suspension Bridge,
Vancouver, British
Columbia**
The Capilano Suspension
Bridge was built in
1889 and completely
reconstructed in 1956. It
crosses the Capilano River
in North Vancouver and,
as the name suggests, is
not a solid walkway. It
stretches more than 140m
(460ft) and is suspended
70m (230ft) above the
Capilano River.

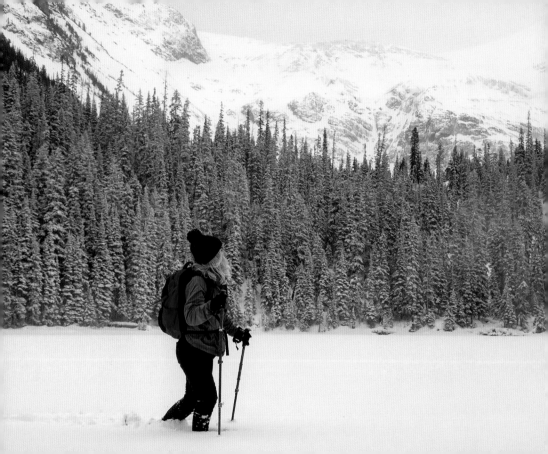

LEFT AND RIGHT:

Snowshoeing, Joffre Lakes, British Columbia

Joffre Lakes, located east of Pemberton, was established in 1988 and attracts tourists who enjoy hiking, snowshoeing and mountain-climbing. It's a habitat for deer, bears and mountain goats.

Designed for walking on rather than sinking into snow, snowshoes are lightweight and crafted with latticework. Originally made of rawhide, today they are made of plastic and metal.

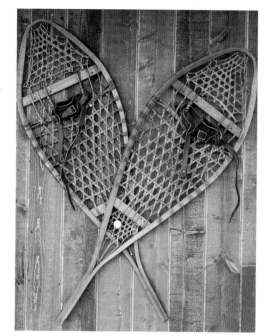

143

RIGHT:
Vancouver and Grouse Mountain, British Columbia

Grouse Mountain was named after the sooty grouse bird found on its slopes. The mountain's climate is moderated by the ocean, so winters aren't very cold.

OPPOSITE, BOTTOM RIGHT:
Financial district, Vancouver, British Columbia

Vancouver's financial district emerged as early as 1907, but expanded more from the 1970s to 1990s. The Cauldron, built for Vancouver's Winter Olympics 2010, can be seen at the base of the photograph.

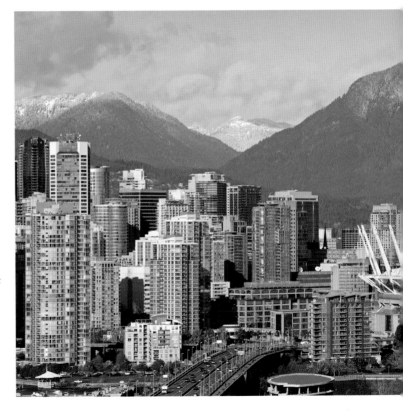

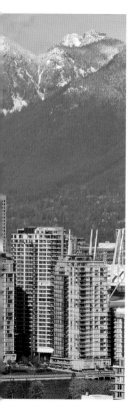

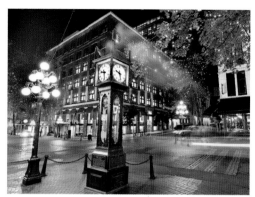

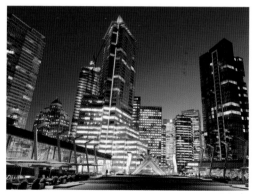

TOP LEFT:

Steam Clock, Gastown, Vancouver, British Columbia

The Gastown Steam Clock is one of the few clocks in the world that uses gas and steam to tell the time. It was constructed in 1977 by horologist Raymond Saunders and metalwork specialist Doug Smith. It is powered by the same steam pipes that provide heat to most of downtown Vancouver.

Gastown is Vancouver's heritage district, with buildings dating back to the early 20th century. It was the city's first downtown district and is named after John 'Gassy Jack' Leighton, a bar owner in the area in the 1860s who was known for his talkative nature and love of storytelling.

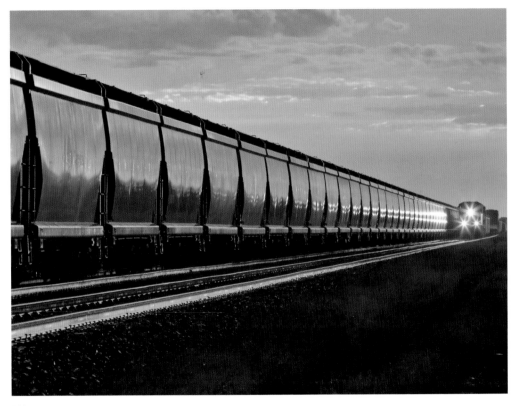

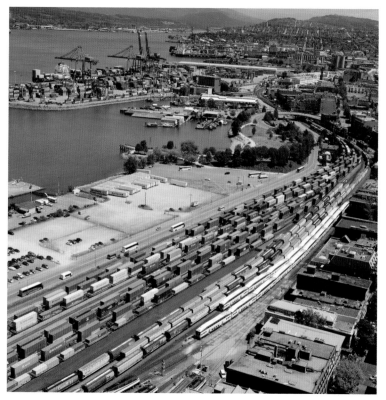

BOTH PHOTOGRAPHS:

Freight trains and freight terminal, Waterfront Station, Vancouver, British Columbia

Canada has 49,442km (30,722 miles) of rail track, which is primarily used by freight traffic. Waterfront Station is Vancouver's main transit terminus. It opened in 1914, having been built by the Canadian Pacific Railway (CPR). Initially, it was the company's Pacific terminus for transcontinental passenger trains to Quebec and Ontario. Today the wider terminal supports the operation of trains, ferries, buses, helicopters and floatplanes.

BOTH PHOTOGRAPHS:

Granville Island Public Market, Vancouver, British Columbia

During The Great Depression of the early 1930s, much of the homeless population of Vancouver lived on Granville Island. Then, during World War II, Wright's Canadian Ropes, the country's largest manufacturer of heavy-duty rope, was headquartered there. In the 1970s, the federal government began converting the building into a public market.

Granville Island Public Market opened in 1979.

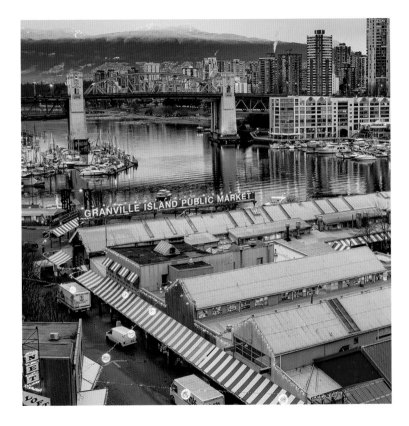

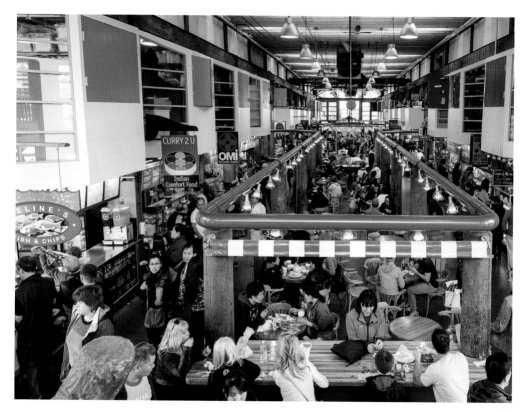

149

Granville Island Public Market, Vancouver, British Columbia
Granville Island Public Market attracts both locals and tourists, with up to 50 vendors selling at a time. Visitors can purchase meat, cheese and fish, much of which is locally sourced.

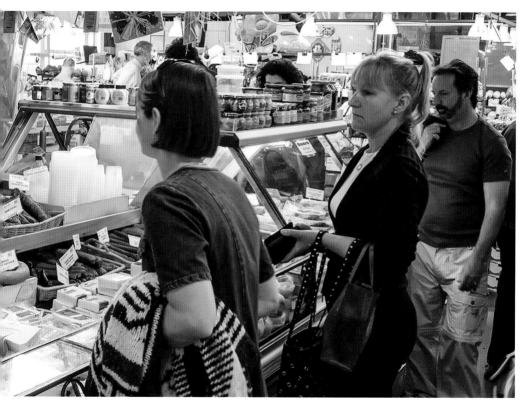

Sea kayaks, Great Bear Rainforest, British Columbia

The Great Bear Rainforest is part of the larger Pacific temperate rainforest ecoregion, the world's largest coastal temperate rainforest. These rainforests are characterized by their proximity to both mountains and oceans. The rainforest is home to salmon, wolves, cougars, and a distinct sub-species of black bear called the Kermode bear.

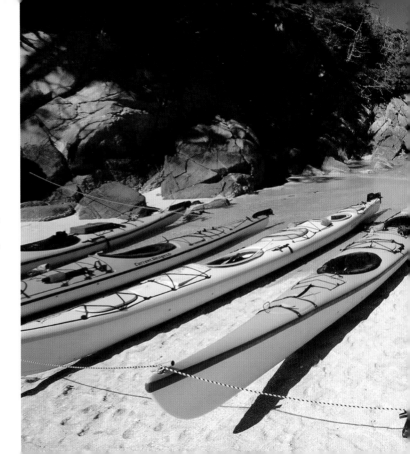

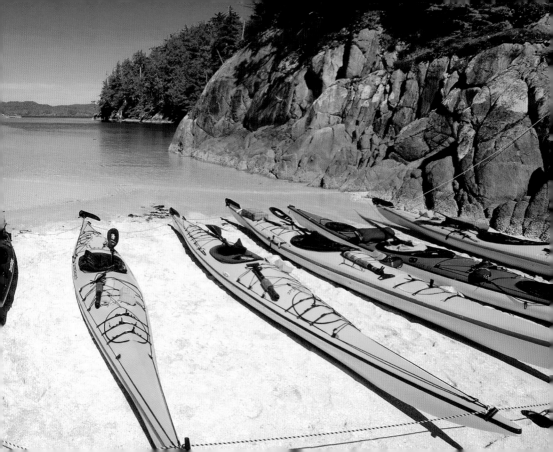

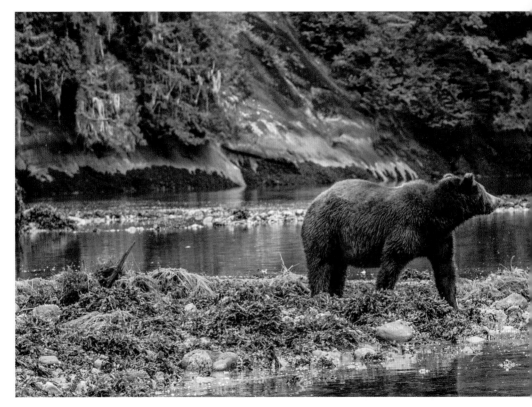

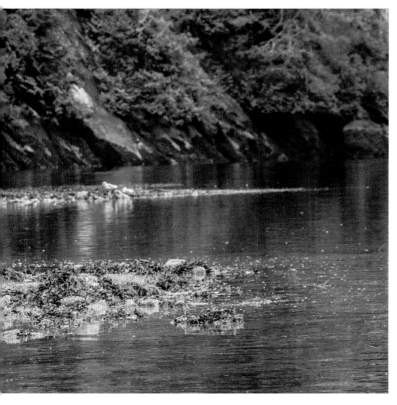

**Grizzly bear,
Great Bear Rainforest,
British Columbia**
Grizzly bears that live near coasts tend to be bigger than the grizzlies that live inland, which explains the massive size of the bears found in British Columbia. Their fur ranges in colour from blonde to black. Male bears can live for up to around 22 years; females tend to have longer lives (as long as 26 years) as they aren't prone to as many fights as male bears. However, 70 per cent of incidents involving the death of a human from a bear attack occur when a mother bear defends her cubs.

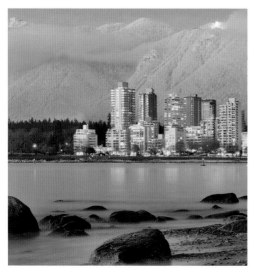

Skyride, Grouse Mountain, British Columbia

It once took four days to climb Grouse Mountain. In 1949, the world's first two-person chairlift was built there. This significantly altered both the journey to the mountain and the time it took to reach it. The Skyride cable car opened in 1966.

ABOVE:

Vancouver, British Columbia

Vancouver is consistently named one of the best cities in the world for quality of life. It has the coolest summer average temperature of all Canadian metropolitan areas because of its coastal climate, but it has a significantly milder winter than many other cities in the country that spend months buried under 10 feet of snow. Grouse Mountain can be seen in the background.

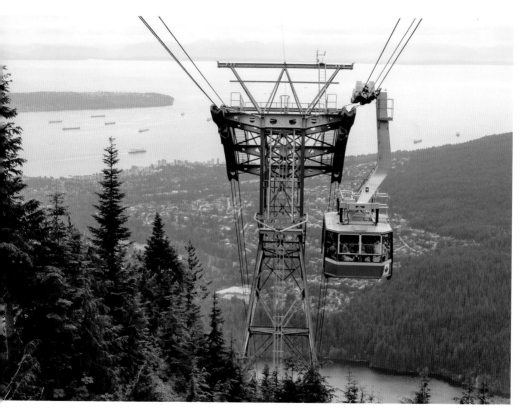

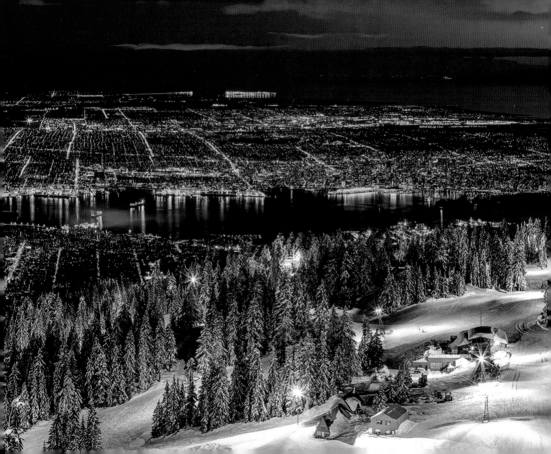

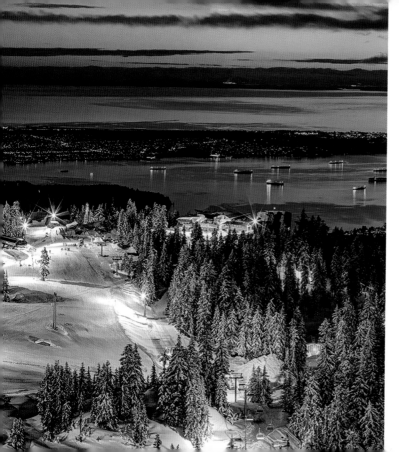

Vancouver seen from Grouse Mountain, British Columbia

Grouse Mountain receives around 305cm (120in) of snow a year. In addition to this, the ski runs are equipped with 37 snow guns to create artificial snow and extend the skiing season.

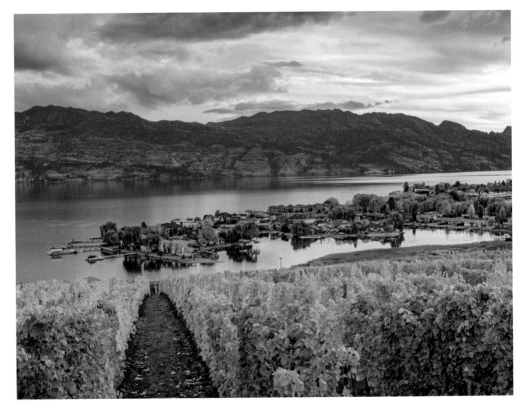

OPPOSITE:
Vineyard, Okanagan Lake, British Columbia
The Okanagan Valley wine region produces more than 80 per cent of all British Columbia's wine, second in Canadian wine production only to Niagara Falls in Ontario.

LEFT:
Rainforest, Pacific Rim National Park Reserve, Vancouver Island, British Columbia
The Pacific Rim National Park is known for its western hemlock spruce and cedar trees, as well as for spectacular hiking opportunities.

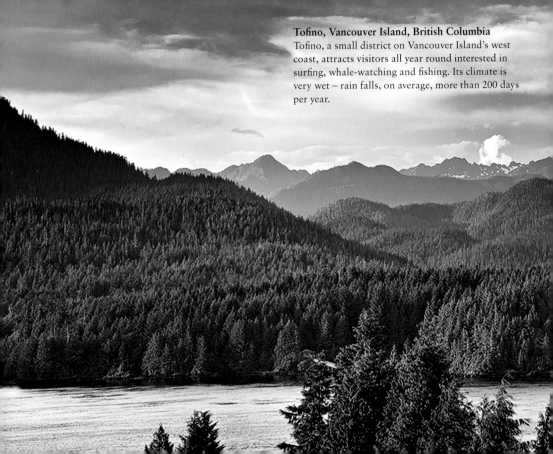

Tofino, Vancouver Island, British Columbia
Tofino, a small district on Vancouver Island's west coast, attracts visitors all year round interested in surfing, whale-watching and fishing. Its climate is very wet – rain falls, on average, more than 200 days per year.

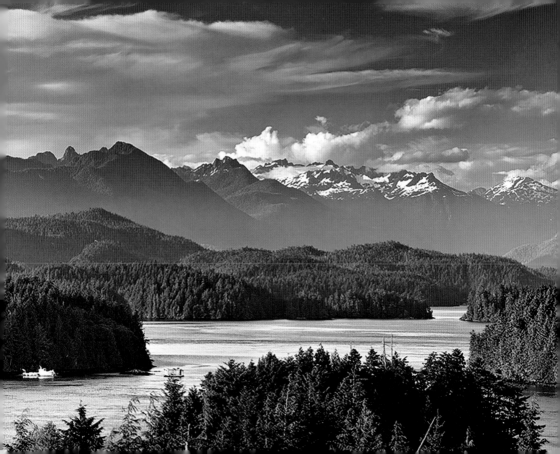

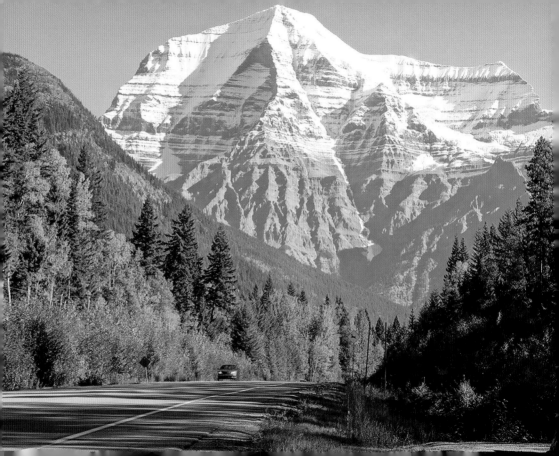

MOUNT ROBSON PARK

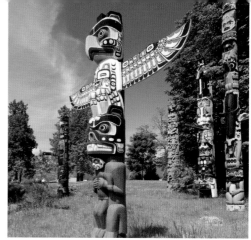

LEFT:

Mount Robson Provincial Park, British Columbia

Mount Robson Park, one of the oldest in British Columbia, contains the headwaters of the Fraser River. Mount Robson itself (pictured) is the highest point in the Canadian Rockies.

ABOVE:

Totem poles, Stanley Park, Vancouver, British Columbia

Stanley Park was not designed by a landscape architect, but is the result of many years of evolution of natural forest and urban space. Some of the original totem poles in the park, made of red cedar wood, date back to the 1880s.

NEAR RIGHT:

Barkerville Historic Town, British Columbia

Barkerville Historic Town and Park has been preserved to commemorate the role that the gold rush played in the development of British Columbia in the 1860s.

FAR RIGHT:

Totem pole

To the northwest First Nations people, totem poles represent cultural heritage, notable events, clan lineage or local legends. The art is carved into large trees, usually western red cedar. The location of a totem pole marks the place of a significant event.

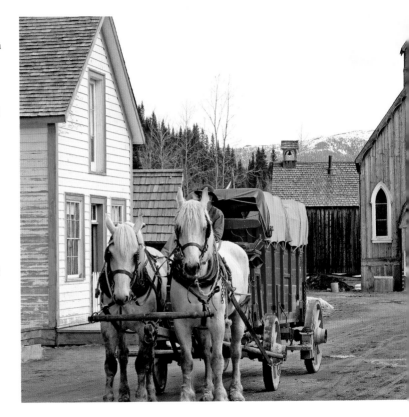

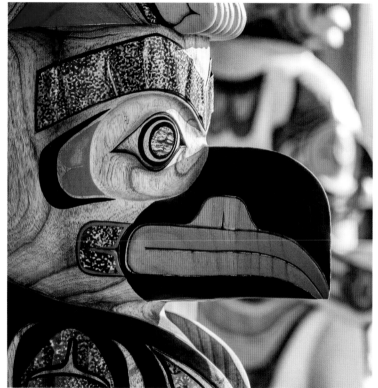

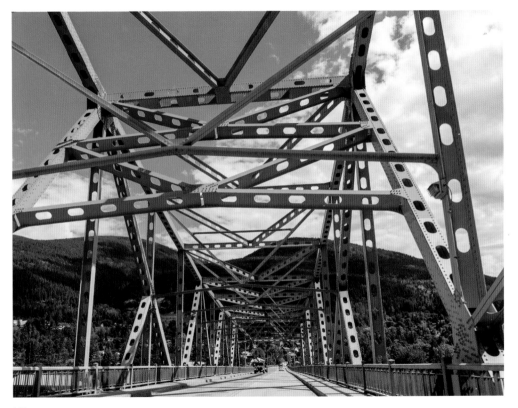

OPPOSITE:

West Arm Bridge, Kootenay River, Nelson, British Columbia

Also known as the Big Orange Bridge, the West Arm Bridge was designed by A.B. Sanderson and Company and constructed in 1957. It is the only way to cross the Kootenay River in Nelson. It replaced a cable ferry.

RIGHT:

Pesuta Shipwreck, Naikoon Provincial Park, Haida Gwaii Archipelago, British Columbia

The *Pesuta* is an 81m (264ft) log barge that was shipwrecked during a winter storm in 1928.

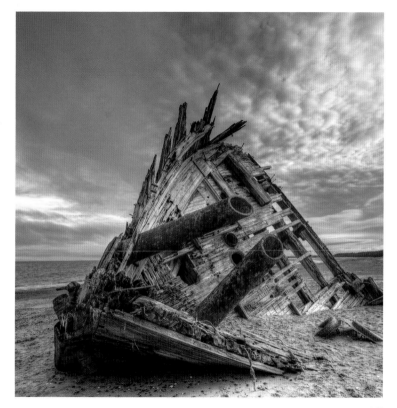

Numa Falls, Kootenay National Park, British Columbia

Numa Falls is a waterfall on the Vermilion River. The park was opened in June 1923, and today many of its visitors swim in its hot springs.

Raccoons, Stanley Park, Vancouver, British Columbia

Although in recent decades raccoons have ventured into more urbanized areas, they have to live near vertical structures – usually trees – to retreat to when they feel threatened. Unusually for a mammal of their size, raccoons climb down trees headfirst, rotating their hind feet so that they are pointing backwards.

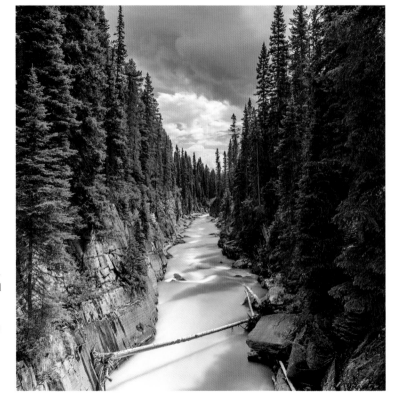

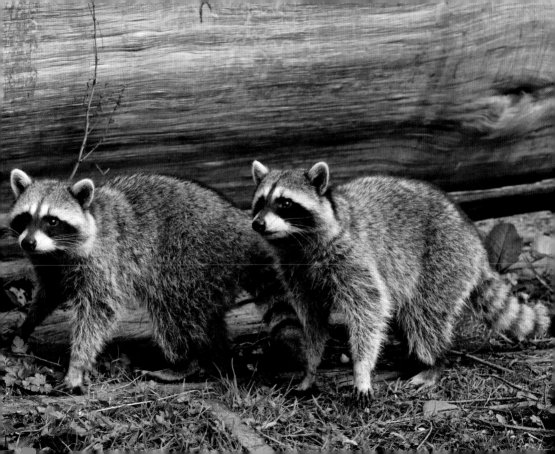

**Kicking Horse River and
Natural Bridge Falls,
Yoho National Park,
British Columbia**

It is said that Kicking
Horse River gets its name
from a historical event.
James Hector, a member
of the Palliser expedition
surveying western Canada
between 1857 and 1860,
was kicked by his horse
while exploring the river.
The name was also given
to the associated Kicking
Horse Pass, which crosses
the Continental Divide,
connecting British
Columbia with the valley
of the Bow River east of
the Rockies.

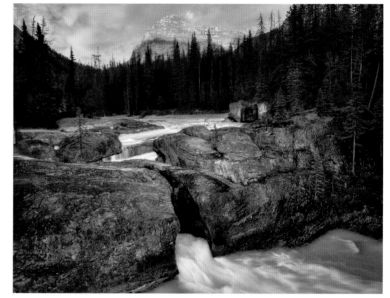

**Sawmill, Midway,
British Columbia**

Many small towns in
British Columbia rely
on the lumber industry,
which has suffered
significantly in recent
years due to a pine beetle
infestation. Forest fires
have also diminished the
amount of usable timber.
In addition, logging has
been restricted, in an
effort to protect caribou
herds in the province.
This has forced the
logging industry's model
to shift from volume-
based to value-based.

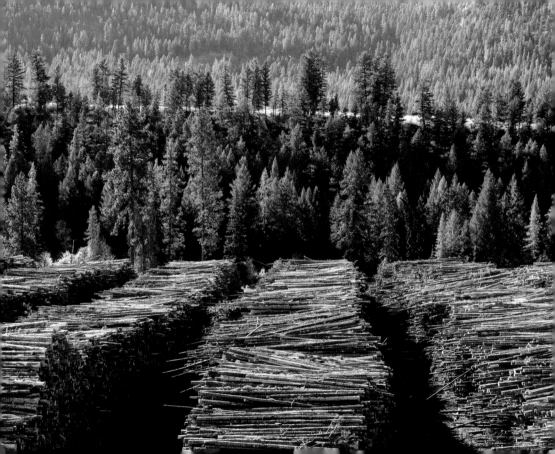

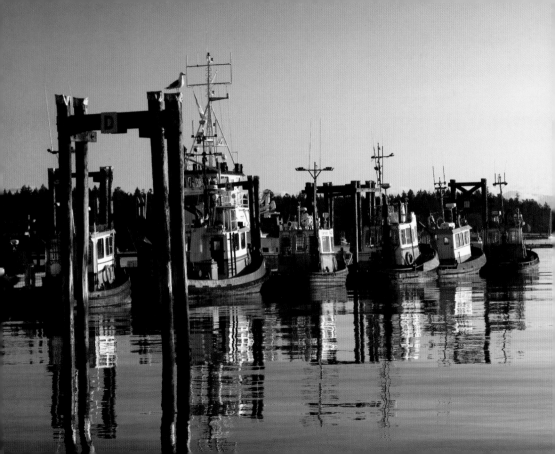

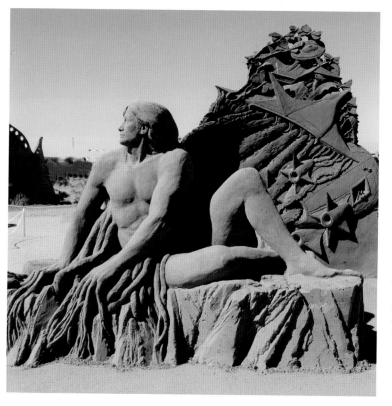

OPPOSITE:
Nanaimo Harbour, Vancouver Island, British Columbia
The city of Nanaimo has one of Canada's longest shorelines, and is known for its floatplanes, diving expeditions and shipwrecks.

LEFT:
Sand sculpture, Parksville, Vancouver Island, British Columbia
The Parksville Sand Sculpture Competition is held every July. Sculptors are given 30 hours to build their creations, based on a different theme each year. The winning sculptures are then placed into an exhibition that runs through to mid-August.

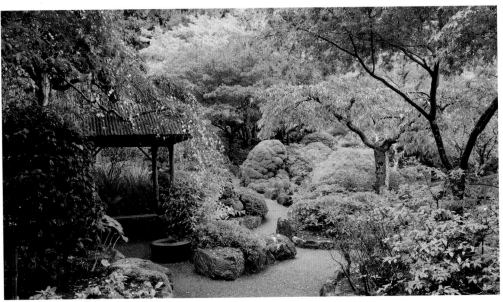

ABOVE:

Butchart Gardens, Victoria, Vancouver Island, British Columbia

Jennie Butchart and her husband moved to Vancouver Island in 1904 to build a cement plant on a limestone deposit. With the limestone soon depleted, the couple envisioned a garden in its place. The gardens were built and expanded between 1906 and 1929, with an Italian Garden and a Rose Garden joining the original Japanese Garden (*pictured*). The couple later gifted the gardens to their grandson and he turned them into the attraction that they are today. Each generation of the Butchart family has developed the garden and the business.

RIGHT:

Port Alberni, Vancouver Island, British Columbia

Port Alberni is at the head of the Alberni Inlet, Vancouver Island's longest inlet. The epicentre of the 1946 Vancouver Island earthquake was close to Port Alberni. Its effect was felt as far away as Oregon in the US.

The city, although on the water, relies on forestry as its main economic source, particularly Douglas fir, cedar and hemlock.

Orca, off Vancouver, British Columbia

Orcas are found repeatedly in indigenous mythology, portrayed as both gentle and vicious animals. They are not a natural threat to humans.

Humpback whale, Victoria, British Columbia

Humpback whales are known for leaping out of water and then slapping its surface with their fins and tails. Although they travel in pods to forage for food and to feed one another, their pods disband within a few hours of formation. They have been known to protect seals from orcas.

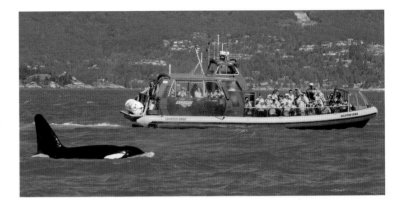

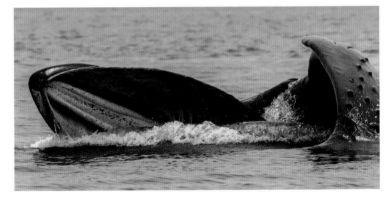

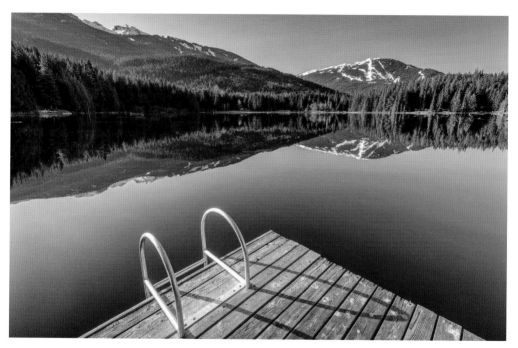

ABOVE:
Lost Lake, Whistler, British Columbia
In summer, Lost Lake can be enjoyed with a swim, while
in winter visitors can cross it on snowshoes.

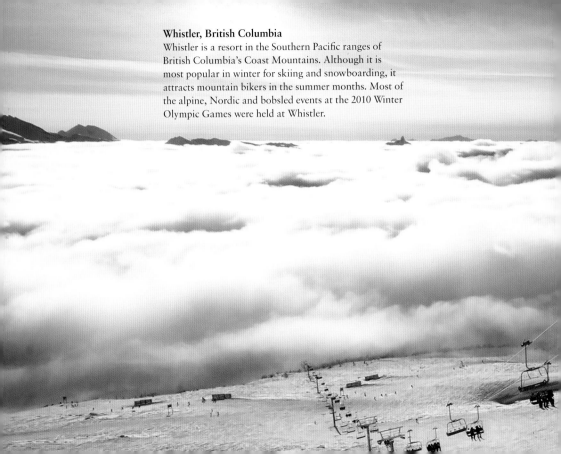

Whistler, British Columbia
Whistler is a resort in the Southern Pacific ranges of British Columbia's Coast Mountains. Although it is most popular in winter for skiing and snowboarding, it attracts mountain bikers in the summer months. Most of the alpine, Nordic and bobsled events at the 2010 Winter Olympic Games were held at Whistler.

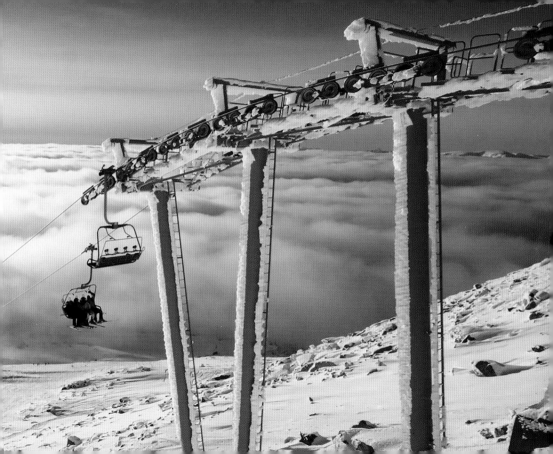

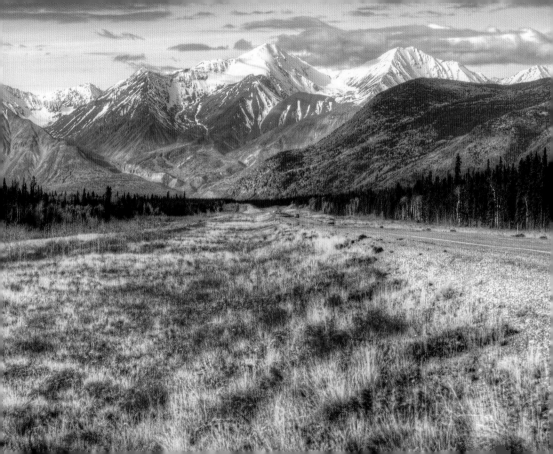

The North

The North, the colloquial name for Northern Canada, consists of the three territories: Yukon, Northwest Territories and Nunavut, which make up almost 40 per cent of Canada's landmass. Only 10 per cent of the land is habitable, which creates stubborn pride in those who do choose to live there. Northern weather, because of its proximity to the Arctic Circle, can involve 24 straight hours of sunlight in summer and the same amount of darkness during the winter.

Yellowknife (population 19,500), the largest community in the Northwest Territories, is the centre of the country's diamond production – Canada is one of the top three countries in the world for the quantity and quality of diamonds.

Inuit people moved east across the Arctic from Alaska to, by the 13th century, Greenland. They largely remained above the Arctic tree line and lived off hunting and whaling. Today they live throughout most of northern Canada, although not in huge numbers.

OPPOSITE:
Whitehorse to Haines Junction, Yukon
From Whitehorse, it is a 154km (96 mile) drive along the historic Alaska Highway to Haines Junction. The routes passes Lake Chadburn, full of beavers, ducks, loons and trout, before entering Miles Canyon, passing Emerald Lake and the tiny Carcross Desert.

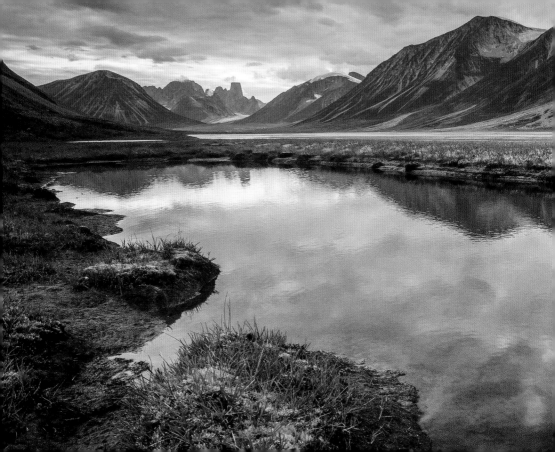

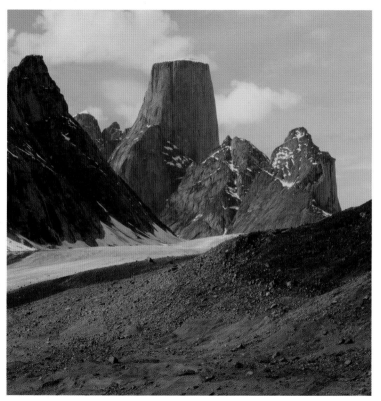

**Akshayuk Pass,
Auyuittuq National
Park, Baffin Island,
Nunavut**
The Akshayuk pass is a
glacial valley surrounded
by the southern Baffin
Mountains. The glaciers
feed into the Owl and
Weasel Rivers. Mount
Asgard can be seen in
the distance.

**Mount Asgard,
Auyuittuq National Park**
Auyuittuq is pronounced
'Ow-you-we-took'. It
comes from an Inuit word
meaning 'the land that
never melts'.

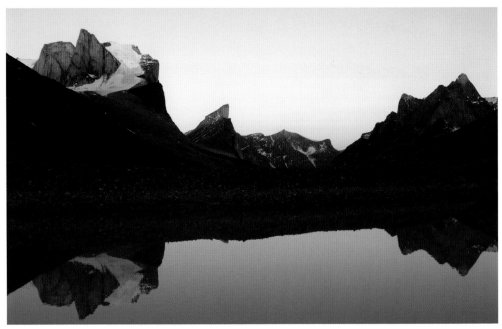

ABOVE:
Summit Lake, Auyuittuq National Park
Auyuittuq National Park is located on eastern Baffin
Island. From Summit Lake it's possible to make a day
hike to see the Turner Glacier.

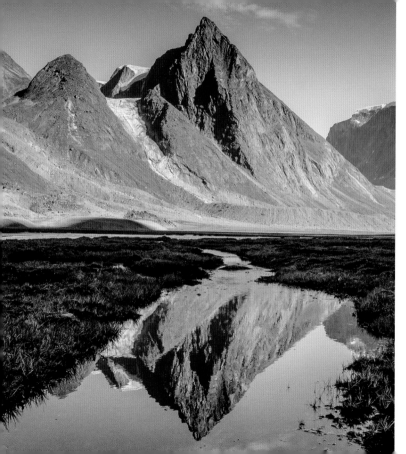

LEFT:
**Akshayuk Pass,
Auyuittuq
National Park**
Akshayuk Pass is a
natural corridor through
a landscape of towering
rock – a refuge for
experienced mountaineers
and backcountry skiers.
It's a zigzag skyline
of granite peaks and
glittering glaciers
overlooking tundra
valleys. Snow geese and
Arctic foxes can be found
there. There are fjords
with winding waterways
filled with narwhal and
ringed seals.

**Alaska Highway
Milepost 635, Watson
Lake, Yukon**

Milepost 635, near
Watson Lake, is one of
the first mileposts on the
Alaska Highway after it
leaves British Columbia.

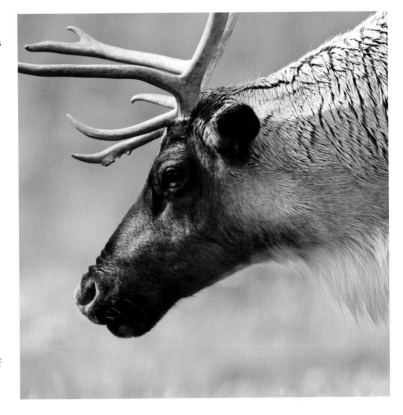

RIGHT:
Caribou
Most of the 15 subspecies of caribou (*Rangifer tarandus*) live above the northern tree line in the Arctic tundra – hence the species other name: tundra reindeer. Caribou have been herded for centuries by circumpolar peoples of the north for food and to provide the muscle for transport. A number of Inuit populations still hunt them for food and for their hides, antlers and bones to make tools.

OPPOSITE:
Mining dredge near Dawson City, Yukon
This is typical of the dredges that dominated the gold fields of the Yukon for more than half a century.

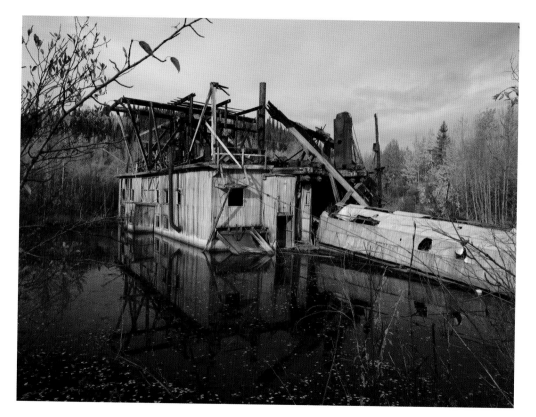

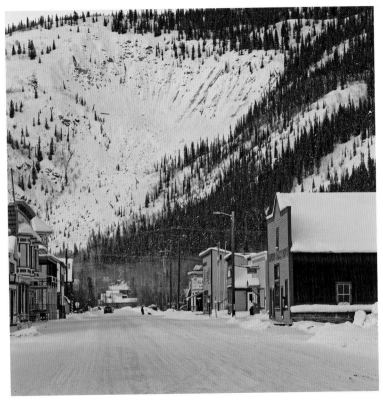

BOTH PHOTOGRAPHS:
Dawson City, Yukon
The centre of the 19th century Klondike Gold Rush, Dawson City, on the Yukon River, has several preserved frontier-style buildings, and even old mail boxes (*right*). Between 1896 and 1898, Dawson City was turned from a First Nations camp into a thriving city of 40,000 people.

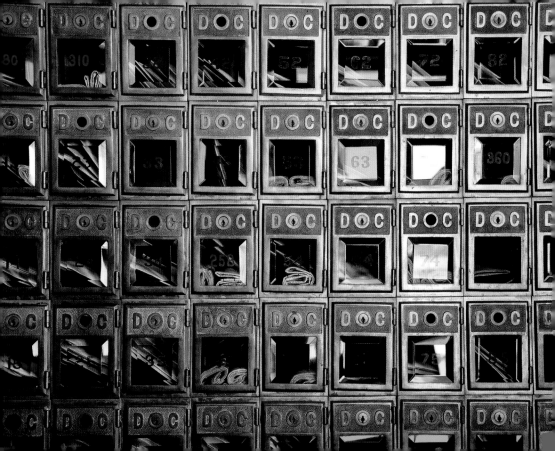

Carcross Desert, Yukon
Although sometimes referred to as the world's smallest desert, these dunes are, unsurprisingly, in a climate too humid to be a true desert. They were created from the silt deposit of glacial lakes, themselves formed in the last glacial period, 115,000 years ago. When the lakes dried, the sand was left behind.

**Tuktoyaktuk Winter
Road, Mackenzie River,
Northwest Territories**

The Tuktoyaktuk Winter
Road was an ice road
that connected the
Northwest Territories
communities of Inuvik
and Tuktoyaktuk, using
the frozen Mackenzie
River delta channels and
the frozen Arctic Ocean.
During the summer, the
area was only accessible
by boat and plane, but
every winter, as soon as
the weather was cold
enough, crews started
building the ice road.

The road closed
permanently in April 2017
at the end of the 2016/17
winter season.

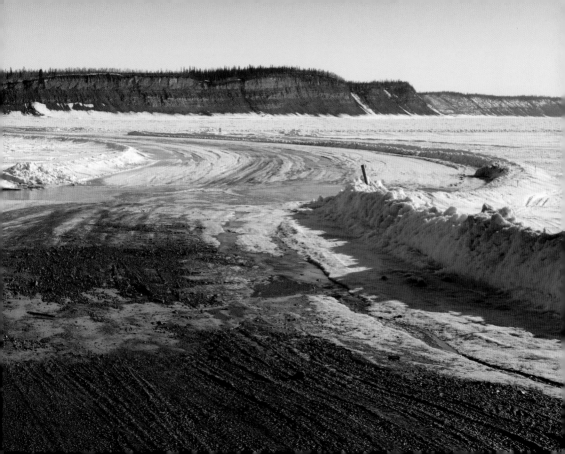

BELOW:

**Snowmobile and sledge, Qikitarjuaq,
Baffin Island, Nunavut**
The snowmobile was introduced to Canada's northern
communities in the 1960s, replacing dog sleds as
northern communities' primary means of transport.

LEFT:

Memorial to the relocated Inuits of the High Arctic, near Resolute Bay, Nunavut

The Arctic Exile Monument commemorates Inuit families from Inukjuak in northern Quebec whom the Canadian government relocated 1943km (1207 miles) in the 1950s to Resolute Bay and Grise Fiord in the High Arctic.

Although the families were told that they were being moved to enjoy better living conditions, critics regarded the relocation as a case of Cold War forced migration, using the 87 people as 'human flagpoles' to reinforce Canada's claim over the disputed Canadian Arctic Archipelago.

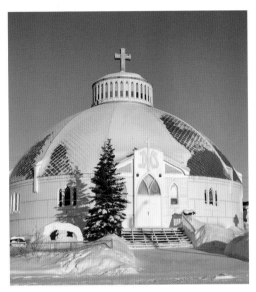

ABOVE:
Our Lady of Victoria Church, Inuvik, Northwest Territories
The shape of Our Lady of Victoria Church was designed to reflect the community's culture – it's also known as 'Igloo Church'. About 60 per cent of Inuvik's population of just over 3000 is Inuvialuit (western Inuit), with another 30 per cent being First Nations.

Inuvik, Northwest Territories

Considered the gateway to the western Arctic, Inuvik is located 200km (124 miles) within the Arctic Circle. While some residents hunt, trap and fish, many local residents are employed by government organizations dedicated to improving the quality of life in the Arctic.

Iqaluit, Nunavut
Iqaluit means 'place of
fish'. The isolated city
is heavily dependent on
expensively imported
supplies. For part of the
year, Nunavut has no
road, rail or even ship
connections to the rest
of Canada, and is only
accessible by air or
ice road.

OPPOSITE, TOP RIGHT:
**Northern Lights, Iqaluit,
Nunavut**
The crystal clear skies in
Iqaluit make it an ideal
place to see the Northern
Lights (*Aurora borealis*).

OPPOSITE, BOTTOM RIGHT:
**Midnight sunset,
Canadian Arctic**
The midnight sun occurs
in midsummer, when the
sun remains visible at the
local midnight time.

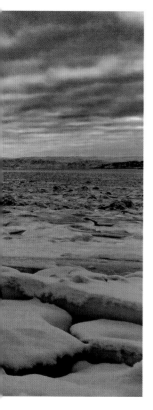
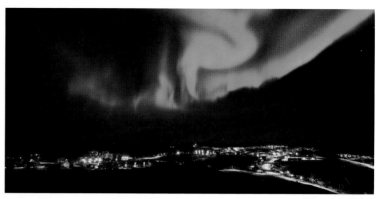

ABOVE:
Sunset, near Naujaat, Nunavut
Naujaat is an Inuit hamlet exactly on the Arctic Circle.
Wildlife in the area includes caribou, polar bears, seals,
whales and walruses.

OPPOSITE:
Abandoned trading post, Fort Ross, Nunavut
This trading post was named after Jonathan Ross,
who led an expedition to the Northwest Territories
from 1829 to 1833. The post was closed in 1948.

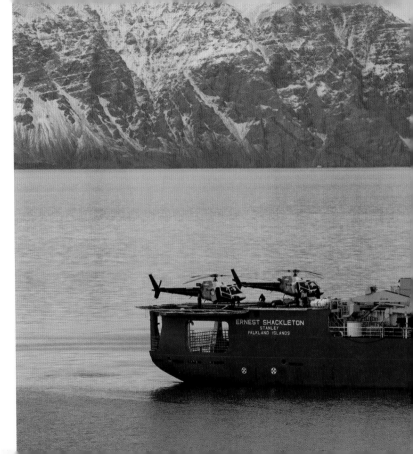

RIGHT:

The Northwest Passage, Nunavut

The icebreaking research vessel RRS *Ernest Shackleton* in the Northwest Passage in 2016. For centuries, European explorers had searched for a navigable sea route from the Atlantic through Arctic Canada to the Pacific. Norwegian Roald Amundsen made the first complete passage from 1903 to 1906. In recent years the decline in Arctic sea ice has made the waters more navigable, and cruises, supported by icebreakers such as this ship, can now be taken through the Northwest Passage.

In 2019, the *Ernest Shackleton* was sold and renamed *Laura Bassi*.

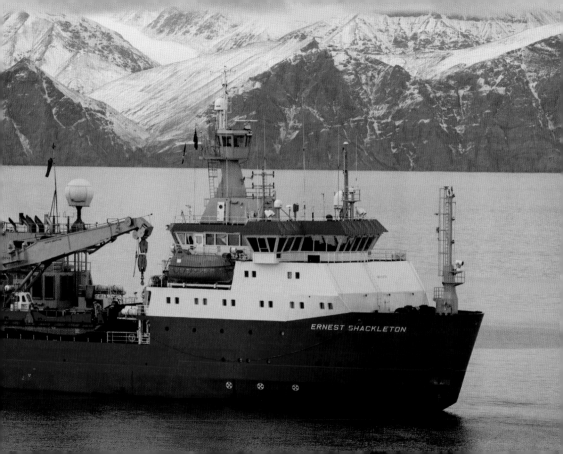

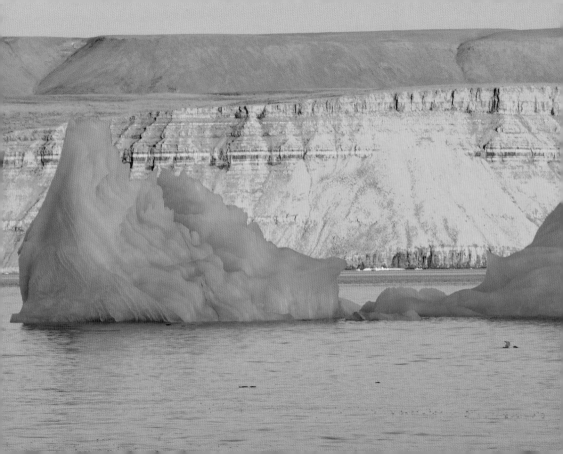

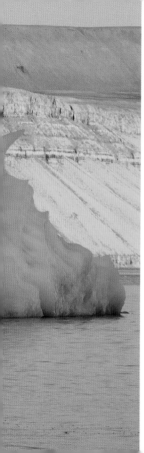

LEFT:

Iceberg, Maxwell Bay, Devon Island, Northwest Passage, Nunavut
The blue of the iceberg in the shade stands in stark contrast to the Arctic tundra behind.

ABOVE:

New Canadian High Arctic Research Station, Cambridge Bay, Nunavut
The sun rises over the Canadian High Arctic Research Station. Work here focuses on Arctic science and technology, ecosystem monitoring and DNA analysis. The research also recognizes the significance of indigenous knowledge in the development of new findings.

209

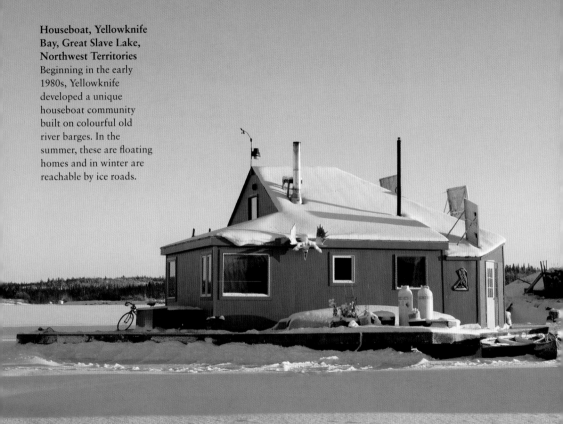

Houseboat, Yellowknife Bay, Great Slave Lake, Northwest Territories Beginning in the early 1980s, Yellowknife developed a unique houseboat community built on colourful old river barges. In the summer, these are floating homes and in winter are reachable by ice roads.

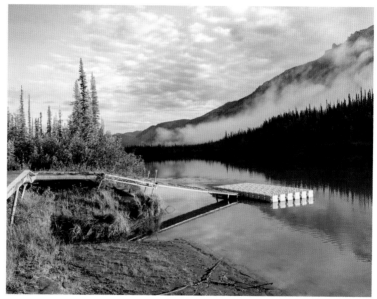

ABOVE:
Floatplane dock, Virginia Falls, Nahanni National Park Reserve, Northwest Territories
This floatplane dock is on the south Nahanni River above Virginia Falls. Nahanni National Park Reserve is only accessible by chartered floatplane, and is ideal for paddling and hiking.

BELOW:

Beaver, Watson Lake, Yukon

This beaver makes its home in Watson Lake, referred to as 'The Gateway to the Yukon'. After South America's capybara, the beaver is the largest rodent in the world.

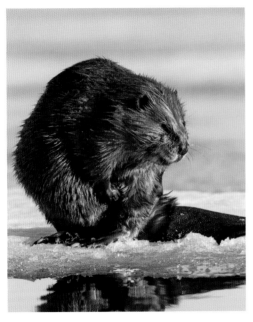

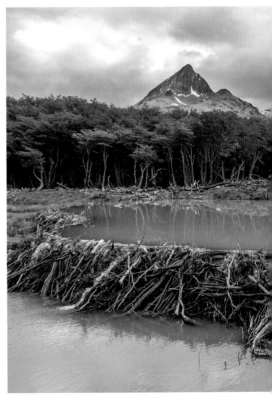

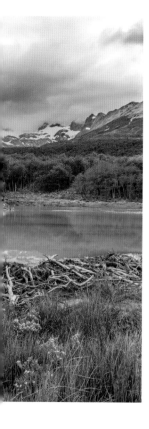

LEFT:
Beaver dam
Beavers gnaw through tree trunks and use branches, fortified with mud and stones, to dam streams. These create ponds in which beavers then construct islands of branches for their lodges.

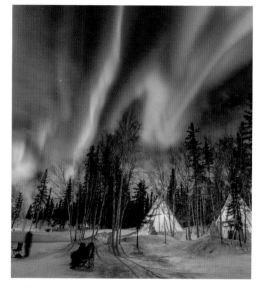

ABOVE:
Aurora Village, Yellowknife, Northwest Territories
Yellowknife and the surrounding area are directly beneath the Aurora Oval, which is a halo-like ring found around both of the Earth's magnetic poles. Yellowknife's flat topography makes it an ideal place to see the *Aurora borealis* (Northern Lights).

Tail of a bowhead whale, Sirmilik National Park, Bylot Island, Nunavut

The bowhead whale, also known as the Arctic right whale (*Balaena mysticetus*), has the largest mouth of any animal in the world. Bylot Island is a migration route for beluga whales, seals, walruses, and bowhead whales.

Floe ice edge, Baffin Bay, Nunavut

As ice moves, it will travel with the ocean currents and Arctic winds. From April to July in Nunavut, birds, walruses, seals, polar bears, narwhals and whales gather along the floe edge.

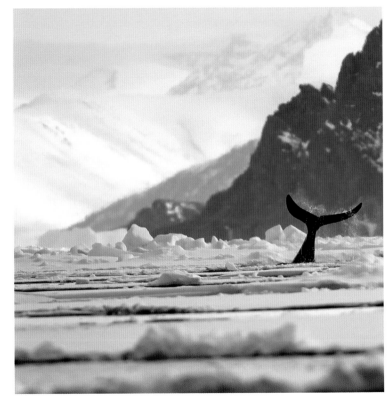

OPPOSITE:
MacBride Museum, Whitehorse, Yukon

The smaller wooden building was once Whitehorse's Government Telegraph Office, built in 1900. With the building unoccupied in 1950, the newly established Yukon Historical Society began using the telegraph office for its local history collection.

The museum is named after Bill MacBride, one of the historical society's founders.

RIGHT:
Starry Night, Whitehorse, Yukon

The clear skies in the winter months make Whitehorse an excellent spot to enjoy the night sky.

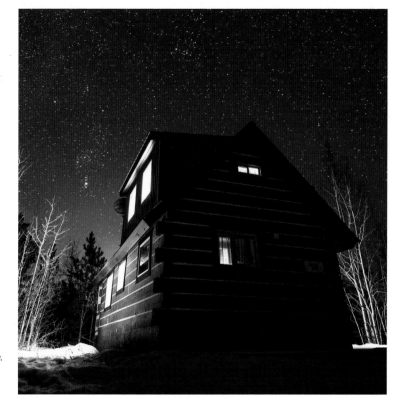

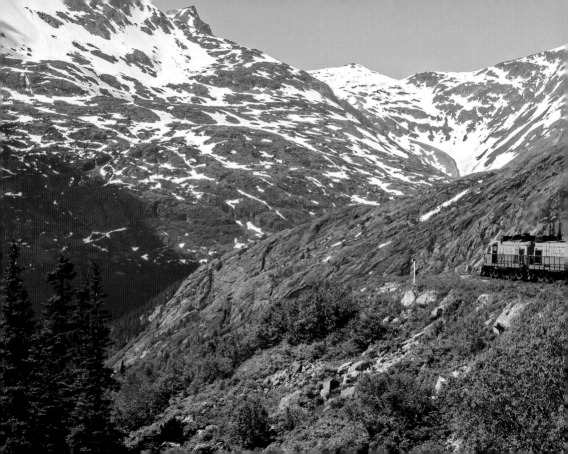

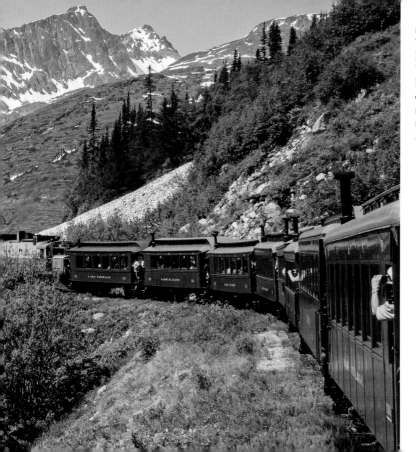

White Pass & Yukon Route Railroad

White Pass & Yukon Route Railroad has its origin in the 1900s gold rush. The narrow-gauge railroad links far eastern Alaska with the Yukon.

219

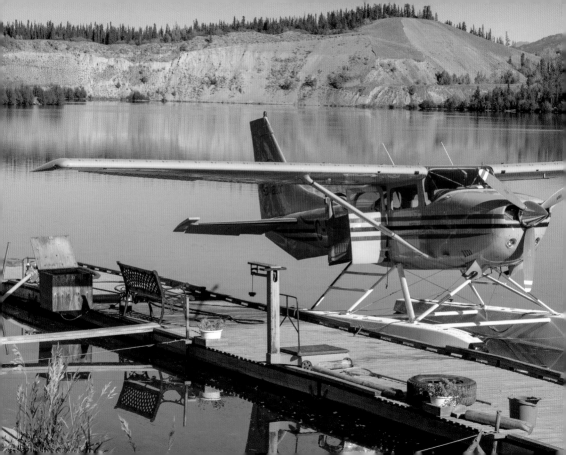

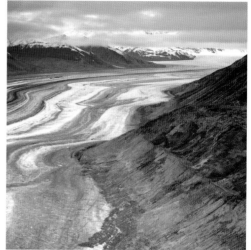

LEFT:

Seaplane, Yukon River, near Whitehorse, Yukon
With many places inaccessible by road, seaplanes like this Cesna 206 are a vital means of transport and communication.

ABOVE:

Kluane National Park and Reserve, Yukon
Kluane National Park and Reserve is home to Canada's largest ice field and to Mount Logan, which, at 5959m (19,500ft), is the country's highest peak.

221

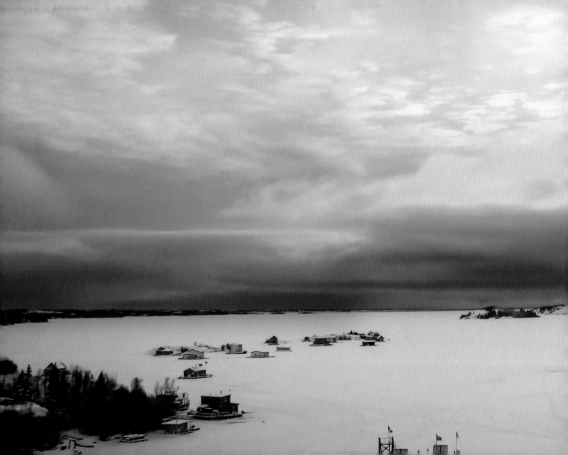

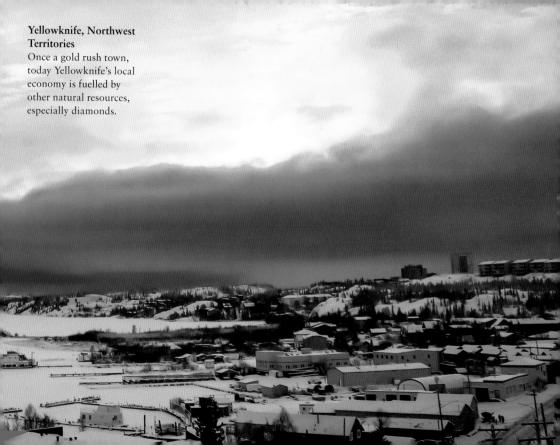

Yellowknife, Northwest Territories
Once a gold rush town, today Yellowknife's local economy is fuelled by other natural resources, especially diamonds.

Picture Credits

Alamy: 14 top left (Stock Connection/Steve Smith), 31 (Bill Gozansky), 57 (Hemis/Gregory Gerault), 171 (Radius Images), 172 (Dennis Frates), 178 top (Simon Pierce), 198 (Jeremy Williams), 206/207 (Ian H), 208 (Image Broker/Egmont Strigl), 214 (Blickwinkel), 215 (Andre Gilden)

Alamy/All Canada Photos: 21 (Garry Black), 30 (David Nunuk), 42 (Barrett & MacKay), 44/45 (Michelle Valberg), 111 (Dave Reede)

Dreamstime: 8 (Tom Baker), 14 right (Megan Lorenz), 16 (Miles Astray), 18 both (Stephan Pietzko), 22 (Susan Kanfer), 28 (Paul McKinnon), 33 (Caubaydon), 38/39 (Paul McKinnon), 46 (Guoqiang Xue), 49 (Christian Fernandez), 59 (Kit Leong), 73 (Pavel Cheiko), 74 (Howard Sandler), 77 (Helen Filatova), 78 (Snehitdesign), 80 (Isabel Poulin), 81 (Saloni1986), 90 (Adwo), 91 (Steve Kingsman), 93 (Diego Grandi), 94 right (Chon Kit Leong), 95 (Ken Taylor), 98 top (Thomas Nevesely), 100 (Siegfried Schneff), 110 (Jason Yoder), 113 (Vadim Rodnev), 121 (Andrey Gudkov), 124 top left (Robert A Philip), 124 top right (Dan Breckwoldt), 124 bottom (Hellen8), 125 (Ronnie Chua), 126/127 (Rafael Angel Irusta Machin), 128/129 (Jeff Whyte), 131 (Hellen8), 134 (Jeff Whyte), 136 all (Nicolae Mihesan), 150/151 (Deymos), 152/153 (Daniel Lacy), 174 (Jaahnlieb), 175 (Lynda Dobbin Turner), 177 (Roxana Gonzalez), 188/189 (Robert M Braley Jr), 193 (Paul Bielicky), 196/197 (Mady MacDonald), 210 (Sophia Granchinho)

Getty Images: 96 (National Geographic/Pete Ryan), 154/155 (Bobbushphoto)

iStock: 7 (Andy Carton), 106/107 (Mystic Energy)

Shutterstock: 6 (TR Photos), 10 (Maria Pogoda), 11 (Knelsen Photo), 12 (Vadim Petrov), 13 (Josef Hanus), 14 bottom left (Reimar), 15 right (JHVE Photo), 17 (Pi-Lens), 19 (Robert Vincelli), 20 (Paul Pound), 23 (Maurizio De Mattei), 24 (Vadim Petrov), 25 (Kevin Brine), 26/27 (Julie A Lynch), 29 top (Fanfo), 29 bottom (Photominer), 32 (C Gara), 34/35 (G Victoria), 36/37 (Zixian), 40 (Danita Delimont), 41 (Elena Elisseeva), 43 (Doplis), 48 (Saptashaw Chakraborty), 50/51 (Elena Elisseeva), 52 (Paul J Hartley), 53 (Atomazul), 54 (Cheryl Ramalho), 55 (Mircea Costina), 56 (Gus Garcia), 58 (Valleyboi63), 60/61 (Keats Photos), 62/63 (Mariemily Photos), 64 (Harold Stiver), 65 (Bing Wen), 66/67 (Simon Eizner), 68 (Pro Design Studio), 69 (Firefighter Montreal), 70 (TR Photos), 71 (Igor Sh), 72 (Inspired by Maps), 75 (Foodio), 76 (Gregor McDougall), 79 (Glass & Nature), 82 & 83 (Serkan Senturk), 84 (Gagliardi Photography), 85 (Diego Grandi), 86 (Vlad G), 87 (Kate Gottli), 88/89 (Master Photo), 92 (Diego Grandi), 94 left (Jon Bilous), 98 bottom & 99 bottom (James Gabbert), 99 top left (Tyler Olson), 99 top right (GTS Productions), 101 (Ronnie Chua), 102 & 103 (2009fotofriends), 104/105 (Thamyris Salgueiro), 108/109 (Andre Anita), 112 (Globe Guide Media), 114/115 (Henryk Sadura), 116 (Fitzcrittle), 117 (SBshot87), 118/119 (Pierre Williot), 120 (Thomas Barrat), 122/123 (Freebilly Photography), 130 (Ronnie Chua), 132 (F M Monkeys), 133 (Ami Parikh), 135 (T R Photos), 137 (Timothy Hue), 138 (Hannamariah), 140 (Richard A McMillan), 141, 142 (E B Adventure Photography), 143 (Malgorzata Litkowska), 144 (Josef Hanus), 145 top (iviewfinder), 145 bottom (Wangkun Jia), 146 (Pictureguy), 147 (Meunierd), 148 (James Wheeler), 149 (Julien Hautcoeur), 156 (Lijuan Guo), 157 (Hugo Sena), 158/159 (Pierre Leclerc), 160 (Stan Jones), 161 (Sara Winter), 162/163 (Mark Skalny), 162 (Chantal de Bruijne), 165 (Josef Hanus), 166 (Vicki L Miller), 167 (Maridav), 168 (Astrid Hinderks), 169 (B G Smith), 170 (R Classen), 173 (Nalidsa), 176 (2009fotofriends), 178 bottom (P Sahota), 179 (Pierre Leclerc), 180/181 (Robcocquyt), 182 (A Michael Brown), 184 (Ed Dods), 185 & 186 (James Haston), 187 (Ed Dods), 190 (Steve Allen), 191 (Frank Fichtmueller), 192 (Pierre Jean Durieu), 194/195 (Baldas1950), 199 (Kevin Xu Photography), 200 (Mady MacDonald), 201 (James Gabbert), 202, 203 top (Jeff Amantea), 203 bottom (Caro Carrier), 204 (Sophia Granchinho), 205 (Mikhail Shchekoldin), 209 (Sophia Granchinho), 211 (Vadim Gouida), 212 left (Jukka Jantunen), 212 right (O Brasil que poucos conhecem), 213 (Ken Phung), 216 (Reinhard Tiburzy), 217 (Daniel Toh), 218/219 (Rocky Grimes), 220 (Jeff Wodniack), 221 & 222/223 (A Michael Brown)

Acknowledgements

The author wishes to thank Michele Bourgeois for her help in the writing of this book.